THE ROYAL HORTICULTURAL SOCIETY

DIARY 2009

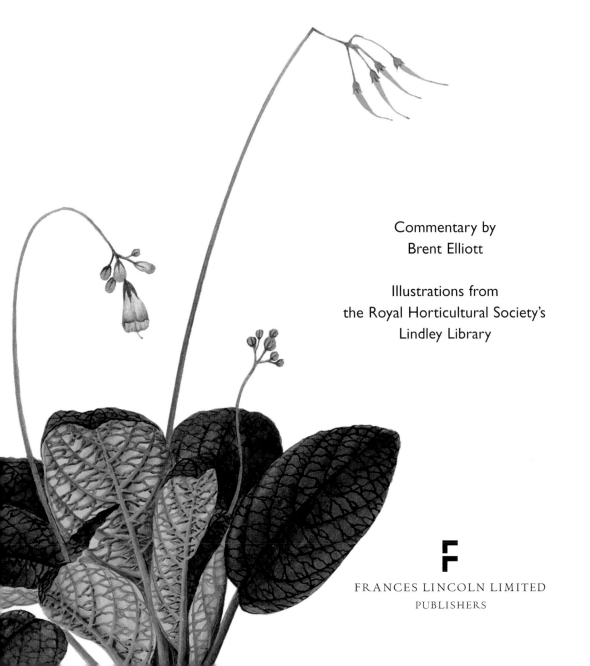

Commentary by
Brent Elliott

Illustrations from
the Royal Horticultural Society's
Lindley Library

F
FRANCES LINCOLN LIMITED
PUBLISHERS

Frances Lincoln Limited
4 Torriano Mews
Torriano Avenue
London NW5 2RZ
www.franceslincoln.com

The Royal Horticultural Society Diary 2009
Copyright © Frances Lincoln limited 2008

Text and illustrations copyright © the Royal Horticultural Society 2008
and printed under licence granted by the Royal Horticultural Society, Registered Charity number 222879/SCO38262.
Every purchase supports the work of the Royal Horticultural Society to advance horticulture and help all gardeners.
For more information visit our website or call 0845 130 4646

An interest in gardening is all you need to enjoy being a member of the RHS.

Website: www.rhs.org.uk

Astronomical information © Crown Copyright. Reproduced by permission of the Controller of Her Majesty's Stationery
Office and the UK Hydrographic Office (www.ukho.gov.uk)

British Library cataloguing-in-publication data
A catalogue record for this book is available from the British Library

ISBN: 978-0-7112-2840-5

Printed in China
First Frances Lincoln edition 2008

RHS FLOWER SHOWS 2009

All shows feature a wide range of floral exhibits staged by the nursery trade, with associated
competitions reflecting seasonal changes and horticultural sundries. With the exception
of the shows held at Cardiff, Malvern, Chelsea, Hampton Court, Tatton Park and Wisley,
all RHS Flower Shows will be held in one or both of the Society's Horticultural Halls in
Greycoat Street and Vincent Square, Westminster, London SW1.

**The dates given are correct at the time of going to press, but before travelling to a
show, we strongly advise you to check with the Compass section of the RHS journal
The Garden, or telephone the 24-hour Flower Show Information Line (020 7649
1885) for the latest details.**

Front cover Chrysanthemum 'Purple Chrystal'. Drawing by an unidentified Chinese artist from the Reeves
collection.

Back cover Cultivar of *Camellia reticulata*. Drawing by an unidentified Chinese artist from the Reeves
collection.

Title page Plectranthus amboinicus. Drawing by an unidentified Chinese artist from the Reeves collection.

Overleaf, left A double red scented cultivar of *Camellia japonica*. Drawing by an unidentified Chinese artist
from the Reeves collection.

CALENDAR 2009

JANUARY
M	T	W	T	F	S	S
			1	2	3	4
5	6	7	8	9	10	11
12	13	14	15	16	17	18
19	20	21	22	23	24	25
26	27	28	29	30	31	

FEBRUARY
M	T	W	T	F	S	S
						1
2	3	4	5	6	7	8
9	10	11	12	13	14	15
16	17	18	19	20	21	22
23	24	25	26	27	28	

MARCH
M	T	W	T	F	S	S
						1
2	3	4	5	6	7	8
9	10	11	12	13	14	15
16	17	18	19	20	21	22
23	24	25	26	27	28	29
30	31					

APRIL
M	T	W	T	F	S	S
		1	2	3	4	5
6	7	8	9	10	11	12
13	14	15	16	17	18	19
20	21	22	23	24	25	26
27	28	29	30			

MAY
M	T	W	T	F	S	S
				1	2	3
4	5	6	7	8	9	10
11	12	13	14	15	16	17
18	19	20	21	22	23	24
25	26	27	28	29	30	31

JUNE
M	T	W	T	F	S	S
1	2	3	4	5	6	7
8	9	10	11	12	13	14
15	16	17	18	19	20	21
22	23	24	25	26	27	28
29	30					

JULY
M	T	W	T	F	S	S
		1	2	3	4	5
6	7	8	9	10	11	12
13	14	15	16	17	18	19
20	21	22	23	24	25	26
27	28	29	30	31		

AUGUST
M	T	W	T	F	S	S
					1	2
3	4	5	6	7	8	9
10	11	12	13	14	15	16
17	18	19	20	21	22	23
24	25	26	27	28	29	30
31						

SEPTEMBER
M	T	W	T	F	S	S
	1	2	3	4	5	6
7	8	9	10	11	12	13
14	15	16	17	18	19	20
21	22	23	24	25	26	27
28	29	30				

OCTOBER
M	T	W	T	F	S	S
			1	2	3	4
5	6	7	8	9	10	11
12	13	14	15	16	17	18
19	20	21	22	23	24	25
26	27	28	29	30	31	

NOVEMBER
M	T	W	T	F	S	S
						1
2	3	4	5	6	7	8
9	10	11	12	13	14	15
16	17	18	19	20	21	22
23	24	25	26	27	28	29
30						

DECEMBER
M	T	W	T	F	S	S
	1	2	3	4	5	6
7	8	9	10	11	12	13
14	15	16	17	18	19	20
21	22	23	24	25	26	27
28	29	30	31			

CALENDAR 2010

JANUARY
M	T	W	T	F	S	S
				1	2	3
4	5	6	7	8	9	10
11	12	13	14	15	16	17
18	19	20	21	22	23	24
25	26	27	28	29	30	31

FEBRUARY
M	T	W	T	F	S	S
1	2	3	4	5	6	7
8	9	10	11	12	13	14
15	16	17	18	19	20	21
22	23	24	25	26	27	28

MARCH
M	T	W	T	F	S	S
1	2	3	4	5	6	7
8	9	10	11	12	13	14
15	16	17	18	19	20	21
22	23	24	25	26	27	28
29	30	31				

APRIL
M	T	W	T	F	S	S
			1	2	3	4
5	6	7	8	9	10	11
12	13	14	15	16	17	18
19	20	21	22	23	24	25
26	27	28	29	30		

MAY
M	T	W	T	F	S	S
					1	2
3	4	5	6	7	8	9
10	11	12	13	14	15	16
17	18	19	20	21	22	23
24	25	26	27	28	29	30
31						

JUNE
M	T	W	T	F	S	S
	1	2	3	4	5	6
7	8	9	10	11	12	13
14	15	16	17	18	19	20
21	22	23	24	25	26	27
28	29	30				

JULY
M	T	W	T	F	S	S
			1	2	3	4
5	6	7	8	9	10	11
12	13	14	15	16	17	18
19	20	21	22	23	24	25
26	27	28	29	30	31	

AUGUST
M	T	W	T	F	S	S
						1
2	3	4	5	6	7	8
9	10	11	12	13	14	15
16	17	18	19	20	21	22
23	24	25	26	27	28	29
30	31					

SEPTEMBER
M	T	W	T	F	S	S
		1	2	3	4	5
6	7	8	9	10	11	12
13	14	15	16	17	18	19
20	21	22	23	24	25	26
27	28	29	30			

OCTOBER
M	T	W	T	F	S	S
				1	2	3
4	5	6	7	8	9	10
11	12	13	14	15	16	17
18	19	20	21	22	23	24
25	26	27	28	29	30	31

NOVEMBER
M	T	W	T	F	S	S
1	2	3	4	5	6	7
8	9	10	11	12	13	14
15	16	17	18	19	20	21
22	23	24	25	26	27	28
29	30					

DECEMBER
M	T	W	T	F	S	S
		1	2	3	4	5
6	7	8	9	10	11	12
13	14	15	16	17	18	19
20	21	22	23	24	25	26
27	28	29	30	31		

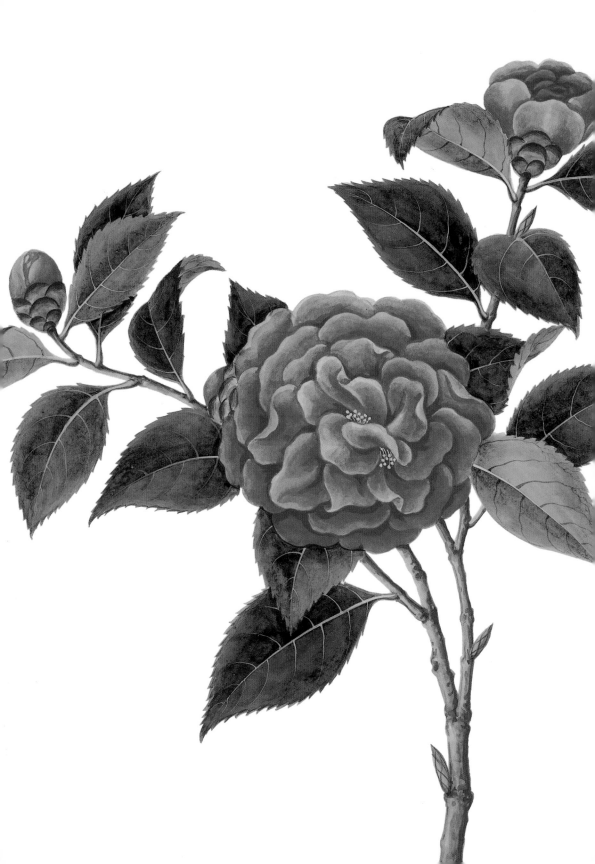

INTRODUCTION

The majority of the illustrations in this diary come from a collection of over 700 drawings made by Chinese artists in the early 19th century, and now housed in the Library of the Royal Horticultural Society. They are known as the Reeves drawings.

John Reeves (1774–1856) was an Inspector of Tea for the East India Company, living and working in China from 1812 to the early 1830s. He was a Corresponding Member of the Horticultural Society, and between 1817 and 1830 he regularly sent both plants and drawings of plants to the Society. Later, he helped to organise Robert Fortune's first expedition to collect plants in China.

The drawings that Reeves sent to the Society were painted by Chinese artists, under Reeves' supervision. They are mostly of garden plants rather than of Chinese wildflowers; Reeves had access to the famous Fa-Tee Nurseries in Canton, and the plants depicted include not only native Chinese plants but also plants that had been brought to eastern Asia and established there by European travellers.

The work is of very high quality, and mixes aspects of the Chinese and European traditions in plant portraiture. For their initial audience, what was most important about them was their rendering of garden plants that had hitherto not been seen in Europe. Joseph Sabine, the Secretary of the Society, and John Lindley, the Vice-Secretary, worked on the drawings, segregating groups depicting cultivated varieties of certain plants – camellias, chrysanthemums, and peonies – into three volumes, while the remainder were bound in five smaller volumes. Those three volumes contain the plants that were deemed most exciting at the time. Camellias had first arrived in Britain in the 1730s, but it was not until the 1790s that double and striped forms began to be introduced, and by the 1820s the range of varieties was increasing. Chinese chrysanthemums first arrived in the 1790s, and 70 cultivars were introduced between 1820 and 1830. Moutans or tree peonies were first seen in Europe in the 1780s, and *Paeonia lactiflora* in 1805.

Sabine used the chrysanthemum drawings in his writings, and recommended the Chinese use of "poetic" names instead of the dull descriptive names so common in England at the time. And so we find that some of the drawings bear captions written by Sabine or Lindley, some with names like 'Semi-double Quilled Pale Orange' and 'Changeable Pale Buff', and others with names rendered from the Chinese, such as 'Yellow Tiger's Claw' and 'White Waves of Autumn'. The translations of the names may not always have been accurate – one which Sabine annotated as 'Purple Pheasant's Tail' should have been 'Purple Phoenix Tail' – but they had an influence on subsequent plant naming in Britain.

In the 1850s, the Society suffered financial disaster, and the original library was sold in 1859. The Reeves drawings went as part of the sale, in two lots. The five volumes of miscellaneous plant portraits returned to the Society with the bequest of Reginald Cory in 1936; the three volumes that Sabine and Lindley had set apart were re-acquired in the 1950s. Many of the drawings had suffered in the interim, from water damage and air pollution, resulting in deterioration of paper and darkening of pigments; their conservation is the subject of a current research project at the RHS.

Some of the illustrations in this diary have been taken from additional collections of oriental drawings in the RHS Library. Four have been taken from a volume of drawings by the Sri Lankan artist, Harmanis De Alwis, who was draughtsman at the Peradeniya Botanic Garden from 1823 to 1861; the drawings were sent to John Lindley by James MacRae, who had formerly been a plant collector for the Society and was the first superintendent of Peradeniya before his early death in 1830. A further three have been taken from an anonymous volume of 19th-century Japanese drawings.

<div align="right">

Brent Elliott
The Royal Horticultural Society

</div>

DECEMBER & **JANUARY**

29 Monday

30 Tuesday

31 Wednesday

New Year's Eve

1 Thursday

New Year's Day
Holiday, UK, Republic of Ireland, Canada, USA,
Australia and New Zealand

2 Friday

Holiday, Scotland and New Zealand

3 Saturday

4 Sunday

First Quarter

Plumeria rubra f. *acutifolia*, a South American plant introduced into east Asia by the Spaniards.
Drawing by an unidentified Chinese artist from the Reeves collection.

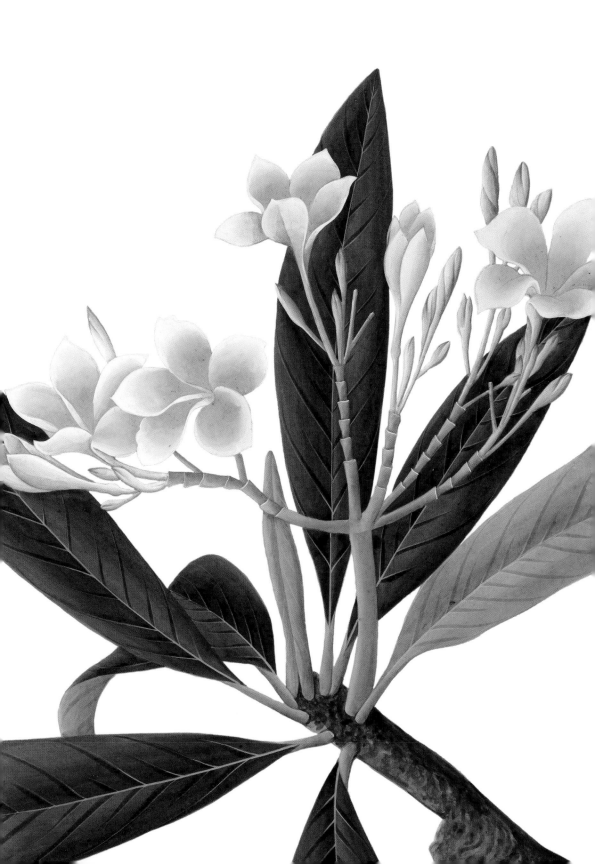

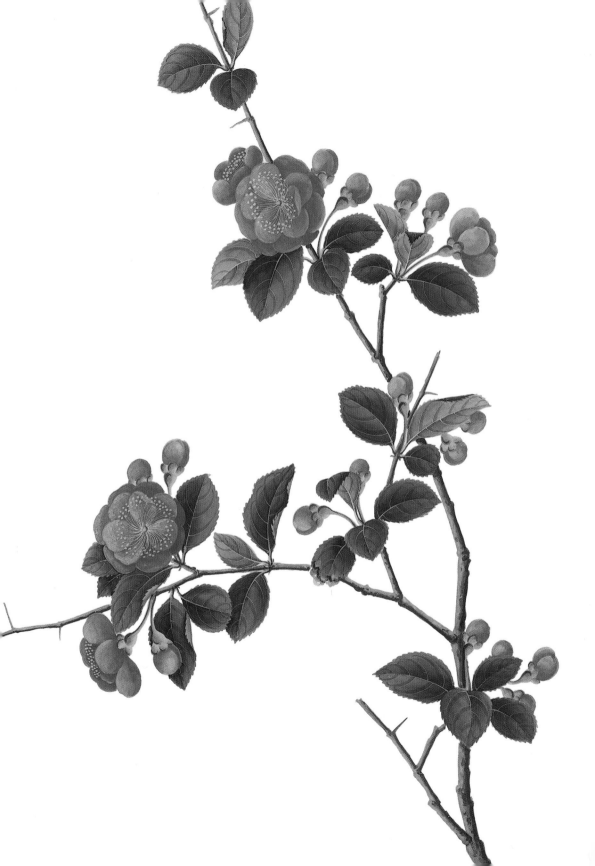

5 Monday

6 Tuesday

Epiphany

7 Wednesday

8 Thursday

9 Friday

10 Saturday

11 Sunday

Full Moon

The Japanese quince, *Chaenomeles japonica*. Drawing by an unidentified Chinese artist from the Reeves collection.

12 Monday

13 Tuesday

14 Wednesday

15 Thursday

16 Friday

17 Saturday

18 Sunday

Last Quarter

An ivory double cultivar of *Camellia japonica*. Drawing by an unidentified Chinese artist from the Reeves collection.

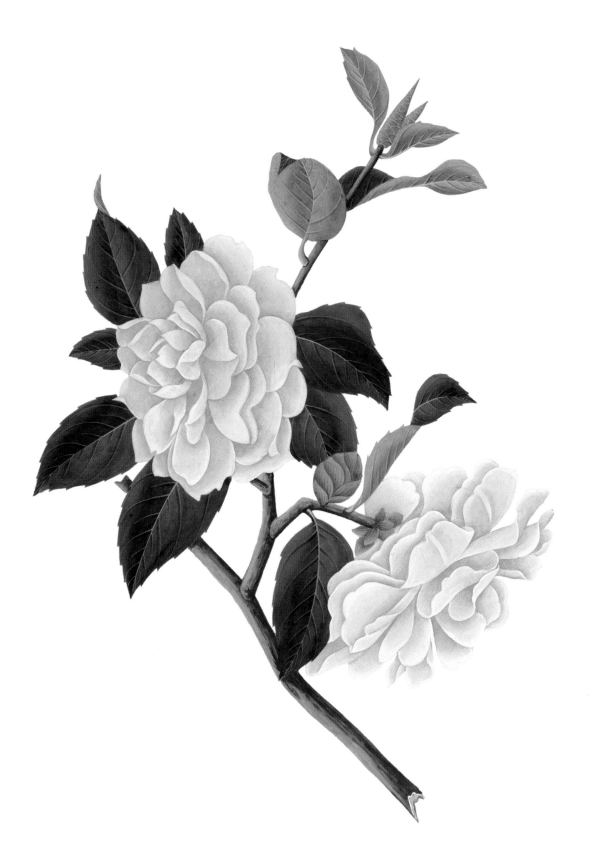

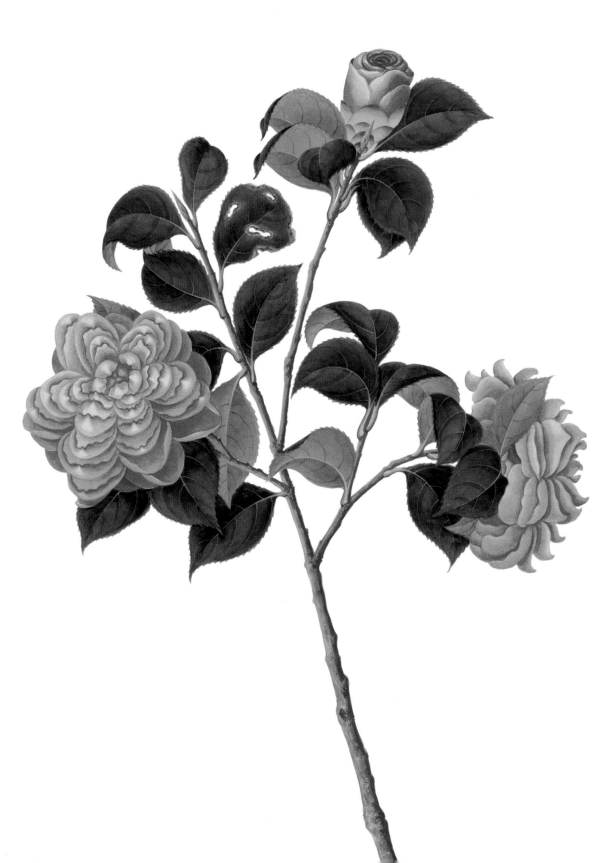

19 Monday

Holiday, USA (Martin Luther King's Birthday)

20 Tuesday

21 Wednesday

22 Thursday

23 Friday

24 Saturday

25 Sunday

Camellia japonica 'Red Hexangular'. Drawing by an unidentified Chinese artist from the Reeves collection.

26 Monday

<div align="right">

New Moon
Chinese New Year
Holiday, Australia (Australia Day)

</div>

27 Tuesday

28 Wednesday

29 Thursday

30 Friday

31 Saturday

I Sunday

Convolvulus siculus, a Mediterranean plant introduced into east Asia by the Spaniards.
Drawing by an unidentified Chinese artist from the Reeves collection.

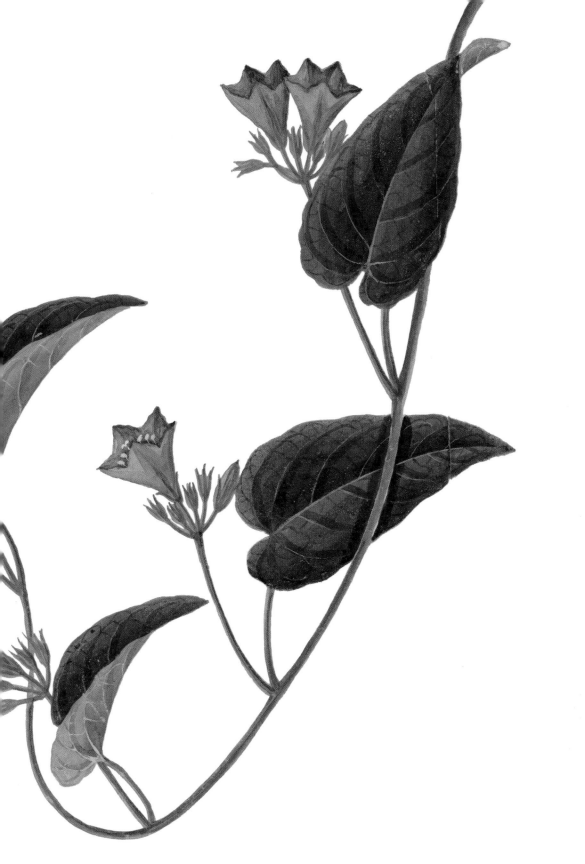

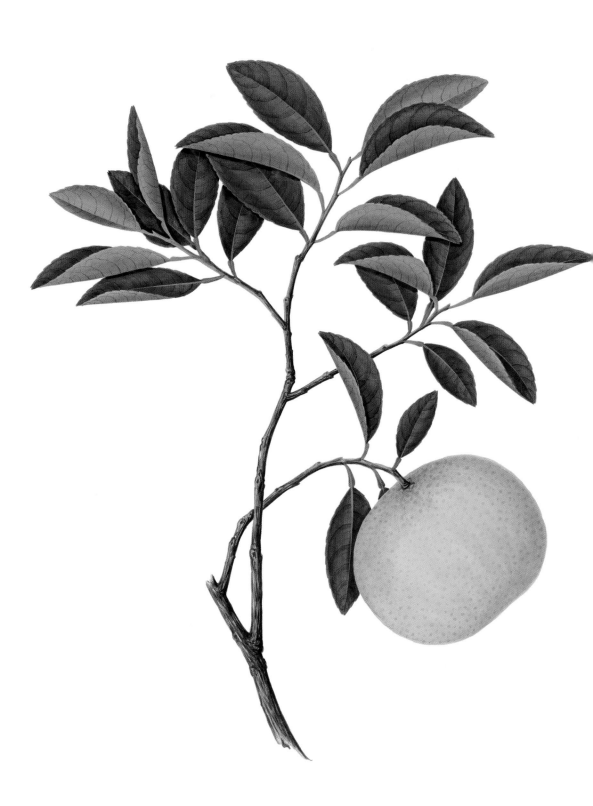

FEBRUARY

2 Monday

First Quarter

3 Tuesday

4 Wednesday

5 Thursday

6 Friday

Accession of Queen Elizabeth II
Holiday, New Zealand (Waitangi Day)

7 Saturday

8 Sunday

'Largest Yellow' orange, a cultivar of *Citrus sinensis*. Drawing by an unidentified Chinese artist from the Reeves collection.

9 Monday

Full Moon

10 Tuesday

11 Wednesday

12 Thursday

Holiday, USA (Lincoln's Birthday)

13 Friday

14 Saturday

St. Valentine's Day

15 Sunday

Prunus davidiana. Drawing by an unidentified Chinese artist from the Reeves collection.

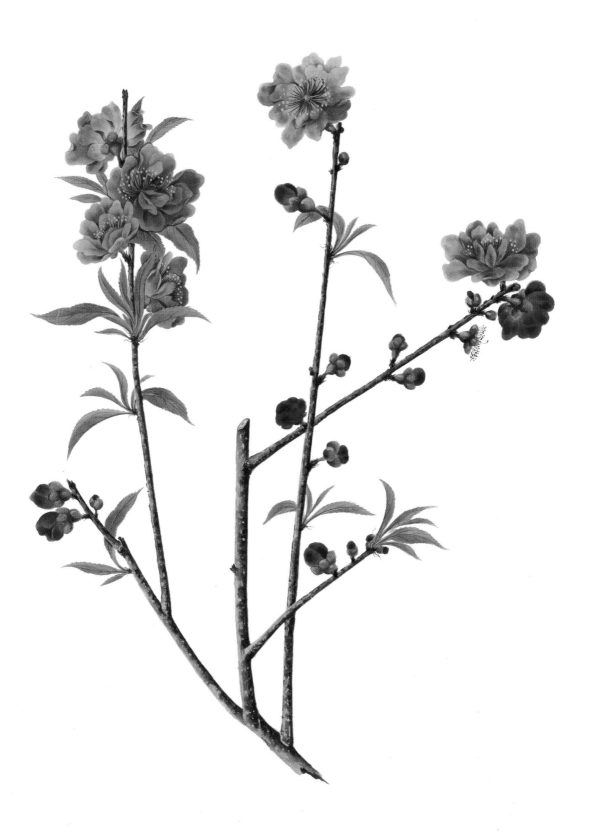

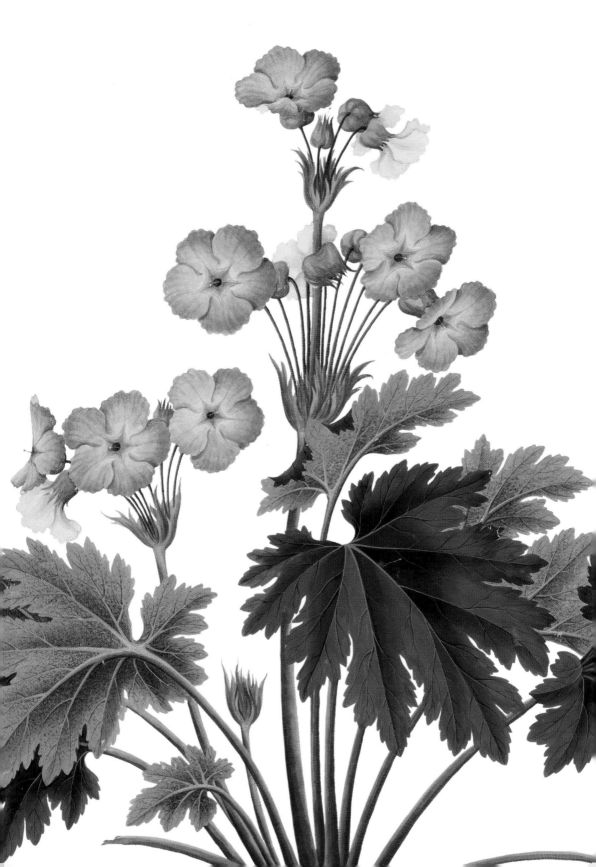

16 Monday

Last Quarter
Holiday, USA (Washington's Birthday)

17 Tuesday

RHS London Flower Show

18 Wednesday

RHS London Flower Show

19 Thursday

20 Friday

21 Saturday

22 Sunday

A cultivar of *Primula sinensis*, tentatively identified on the drawing as a new species.
Drawing by an unidentified Chinese artist from the Reeves collection.

23 Monday

24 Tuesday

Shrove Tuesday

25 Wednesday

New Moon
Ash Wednesday

26 Thursday

27 Friday

28 Saturday

I Sunday

St. David's Day

Single variegated azalea, a cultivar of *Rhododendron indicum*.
Drawing by an unidentified Chinese artist from the Reeves collection.

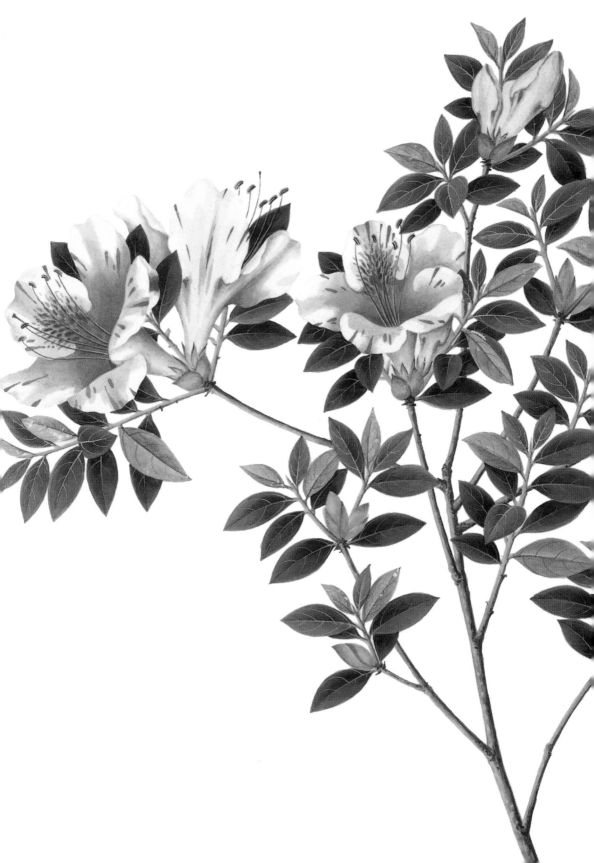

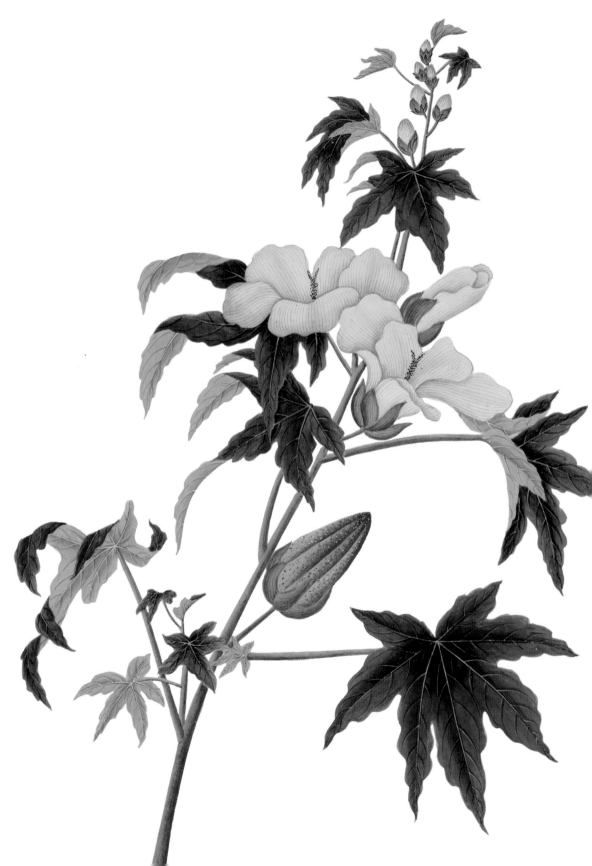

2 Monday

3 Tuesday

4 Wednesday

First Quarter

5 Thursday

6 Friday

7 Saturday

8 Sunday

A yellow form of *Hibiscus syriacus*. Drawing by an anonymous Japanese artist (19th century).

9 Monday

Commonwealth Day

10 Tuesday

11 Wednesday

Full Moon

12 Thursday

13 Friday

14 Saturday

15 Sunday

A cultivar of *Daphne odora*. Drawing by an unidentified Chinese artist from the Reeves collection.

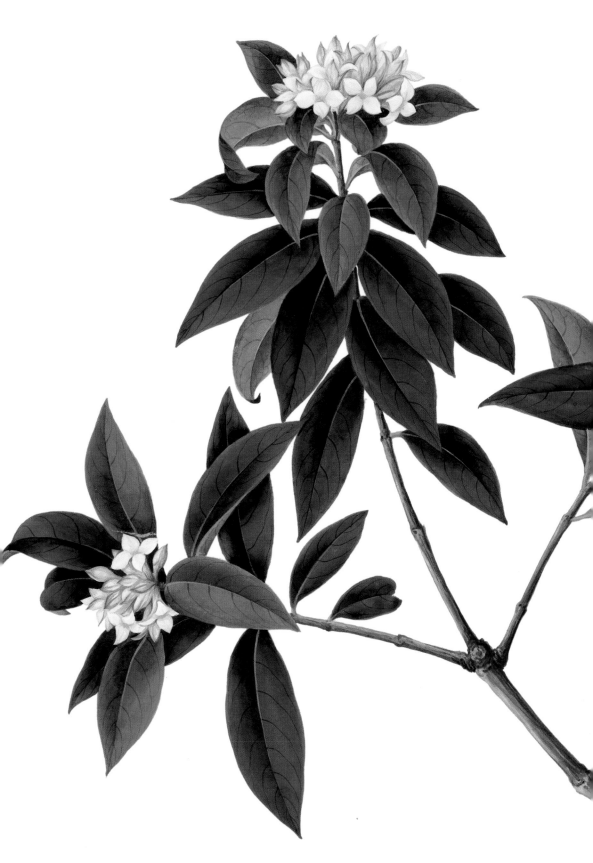

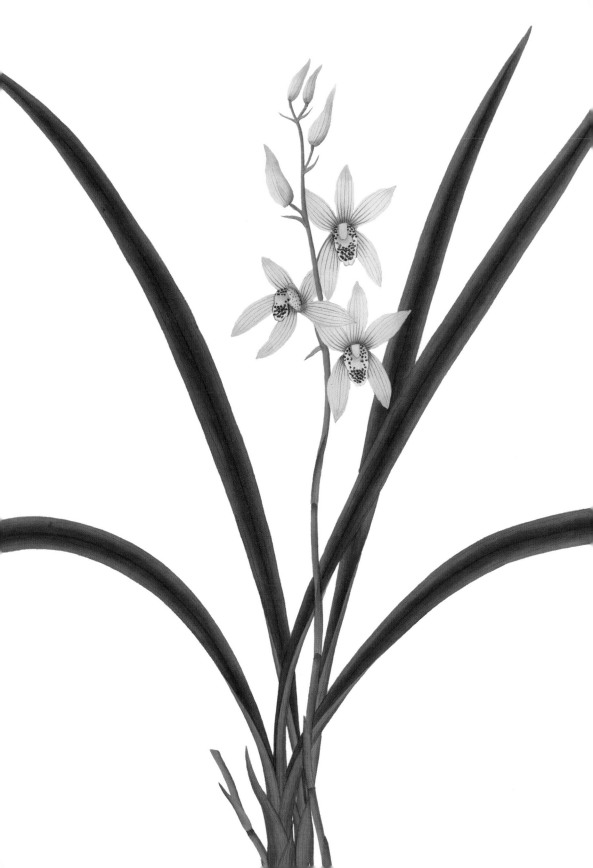

MARCH

16 Monday

17 Tuesday

St. Patrick's Day
Holiday, Northern Ireland and Republic of Ireland

18 Wednesday

Last Quarter

19 Thursday

20 Friday

Vernal Equinox

21 Saturday

RHS London Orchid Show

22 Sunday

RHS London Orchid Show
Mothering Sunday, UK

An orchid variety, *Cymbidium ensifolium* subsp. *haematodes*. Watercolour drawing by Harmanis De Alwis.

23 Monday

24 Tuesday

25 Wednesday

26 Thursday

New Moon

27 Friday

28 Saturday

29 Sunday

British Summer Time begins

Wisteria sinensis. Drawing by an unidentified Chinese artist from the Reeves collection.

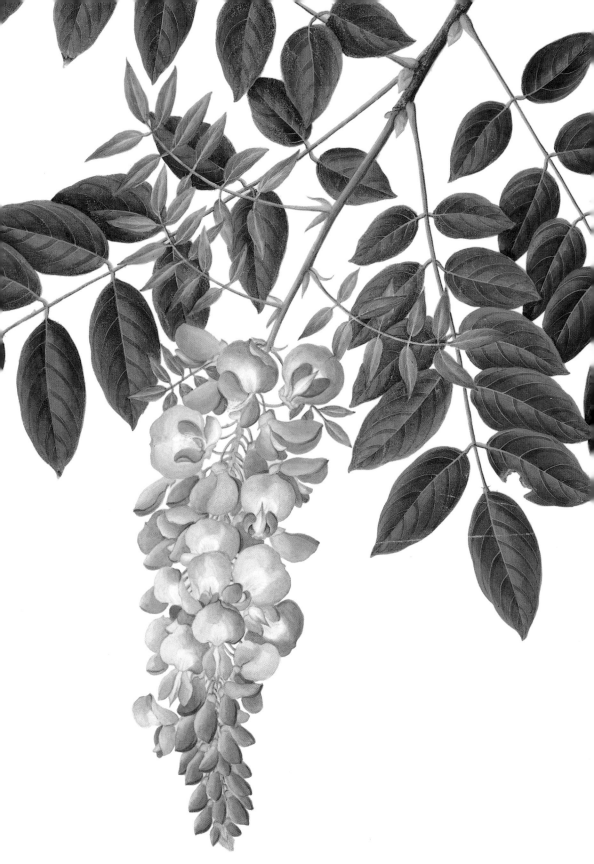

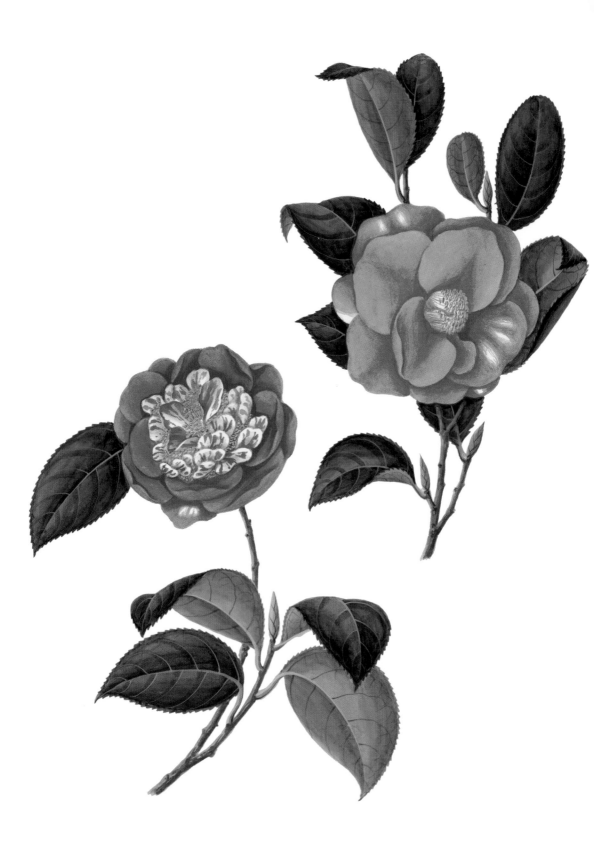

30 Monday

31 Tuesday

1 Wednesday

2 Thursday

First Quarter

3 Friday

4 Saturday

5 Sunday

Palm Sunday

Unnamed cultivars of *Camellia reticulata*. Drawing by an unidentified Chinese artist from the Reeves collection.

6 Monday

7 Tuesday

8 Wednesday

9 Thursday

Full Moon
Maundy Thursday
Passover (Pesach), First Day

10 Friday

Good Friday
Holiday, UK, Canada, USA, Australia and New Zealand

11 Saturday

12 Sunday

Easter Sunday

Lilium longiflorum. Drawing by an unidentified Chinese artist from the Reeves collection.

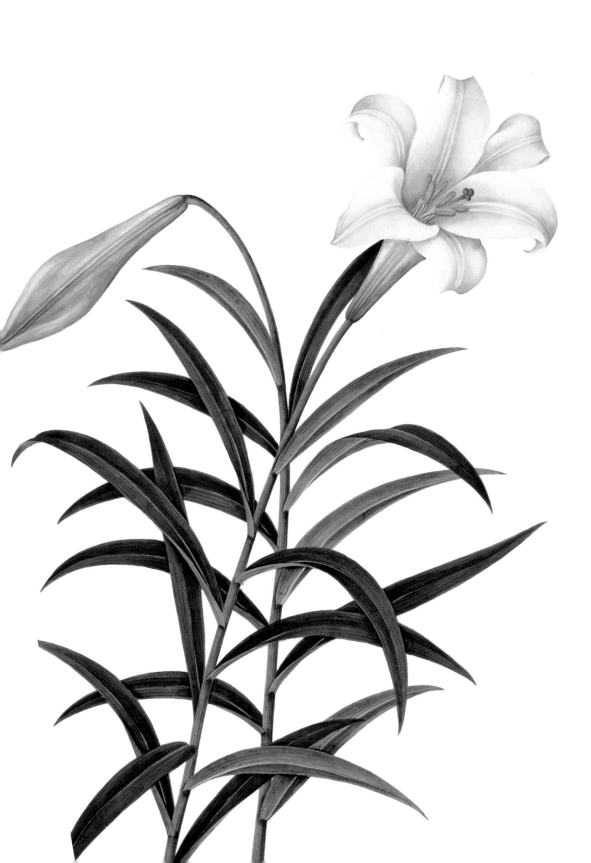

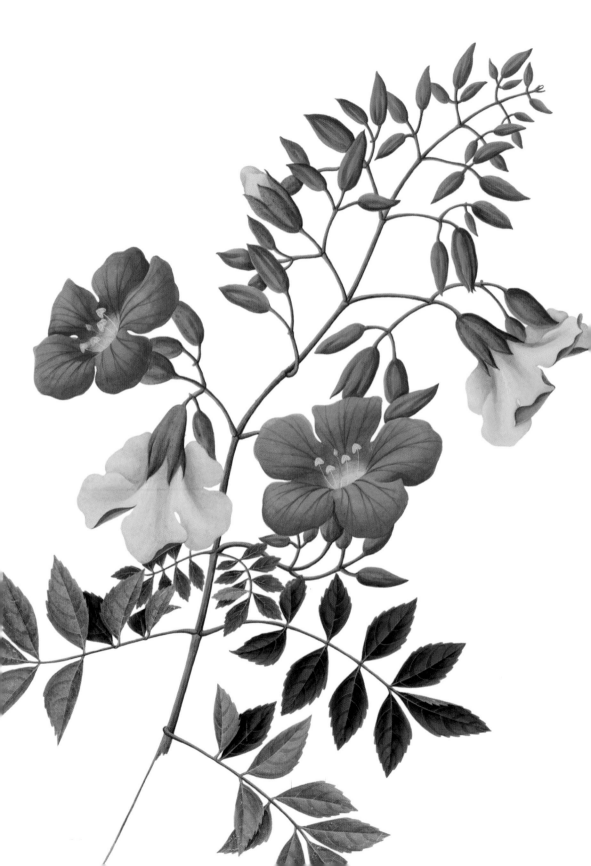

13 Monday

Easter Monday
Holiday, UK (exc. Scotland), Republic of Ireland, Canada,
Australia and New Zealand

14 Tuesday

15 Wednesday

Passover (Pesach), Seventh Day

16 Thursday

Passover (Pesach), Eighth Day

17 Friday

Last Quarter

18 Saturday

19 Sunday

A cultivar of *Campsis grandiflora*. Drawing by an unidentified Chinese artist from the Reeves collection.

20 Monday

21 Tuesday

RHS London Flower Show
Birthday of Queen Elizabeth II

22 Wednesday

RHS London Flower Show

23 Thursday

St. George's Day

24 Friday

25 Saturday

New Moon
Holiday, Australia and New Zealand (Anzac Day)

26 Sunday

A species of *Thibaudia*, a South American genus introduced into eastern Asia by the Spanish;
watercolour drawing by Harmanis De Alwis.

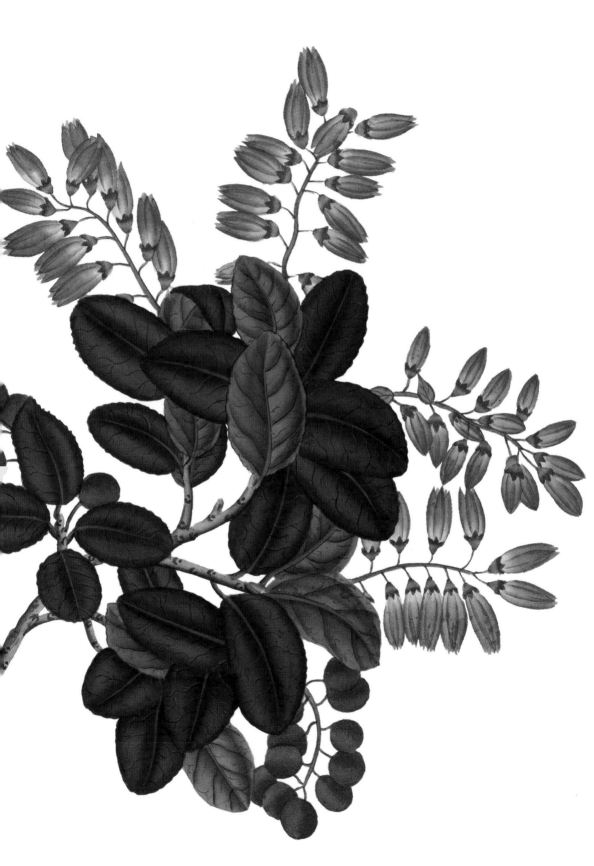

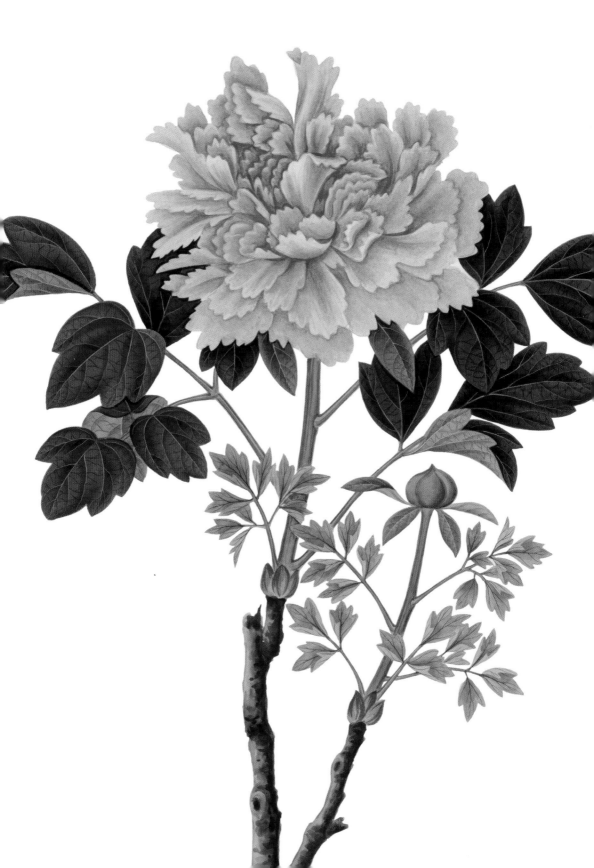

27 Monday

28 Tuesday

29 Wednesday

30 Thursday

1 Friday

First Quarter

2 Saturday

3 Sunday

A double pink cultivar of *Paeonia lactiflora*. Drawing by an unidentified Chinese artist from the Reeves collection.

4 Monday

Early Spring Bank Holiday, UK and Republic of Ireland

5 Tuesday

6 Wednesday

7 Thursday

Malvern Spring Gardening Show

8 Friday

Malvern Spring Gardening Show

9 Saturday

Full Moon
Malvern Spring Gardening Show

10 Sunday

Malvern Spring Gardening Show
Mother's Day, USA, Canada, Australia and New Zealand

Ipomoea cairica. Drawing by an unidentified Chinese artist from the Reeves collection.

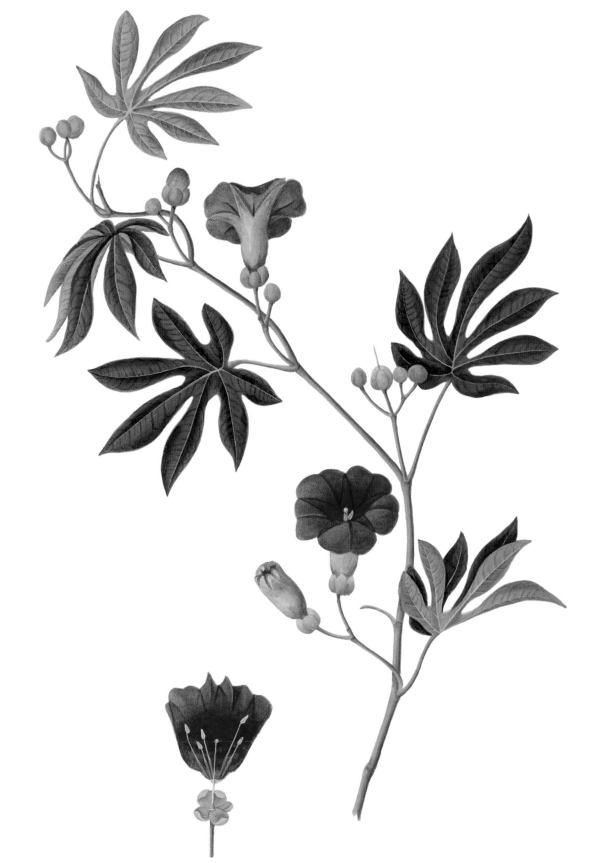

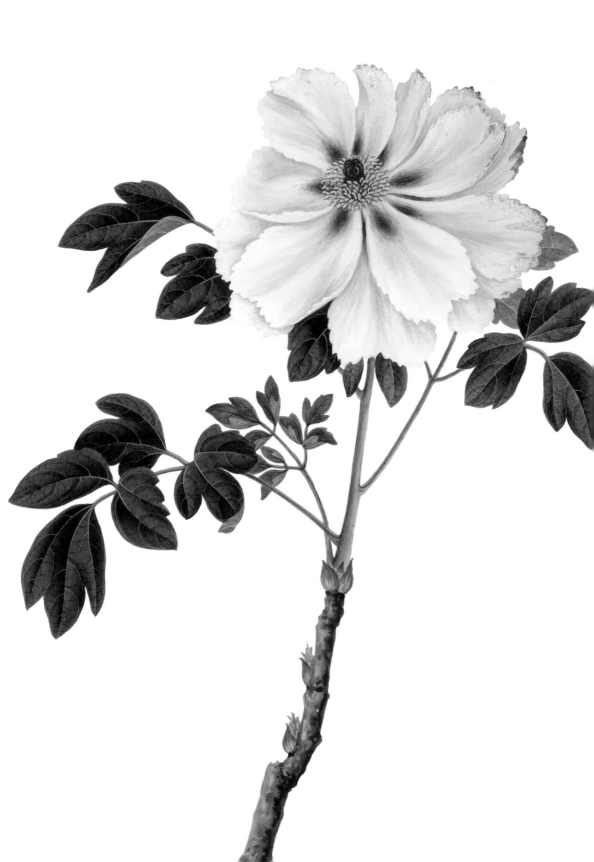

11 Monday

12 Tuesday

13 Wednesday

14 Thursday

15 Friday

16 Saturday

17 Sunday

Last Quarter

A cultivar of the tree peony, *Paeonia suffruticosa* 'Papaveracea'.
Drawing by an unidentified Chinese artist from the Reeves collection.

18 Monday

<div align="right">Holiday, Canada (Victoria Day)</div>

19 Tuesday

<div align="right">RHS Chelsea Flower Show</div>

20 Wednesday

<div align="right">RHS Chelsea Flower Show</div>

21 Thursday

<div align="right">RHS Chelsea Flower Show
Ascension Day</div>

22 Friday

<div align="right">RHS Chelsea Flower Show</div>

23 Saturday

<div align="right">RHS Chelsea Flower Show</div>

24 Sunday

<div align="right">*New Moon*</div>

Lonicera japonica. Drawing by an unidentified Chinese artist from the Reeves collection.

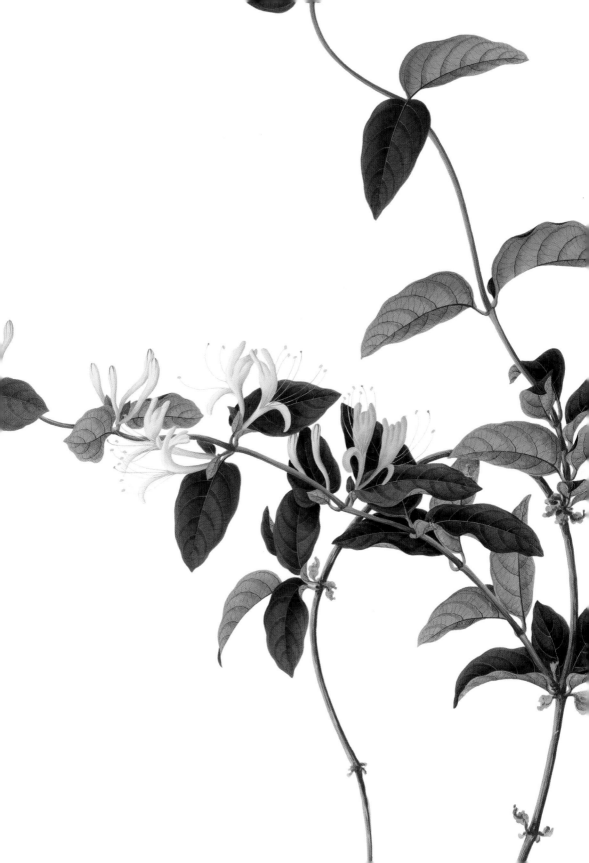

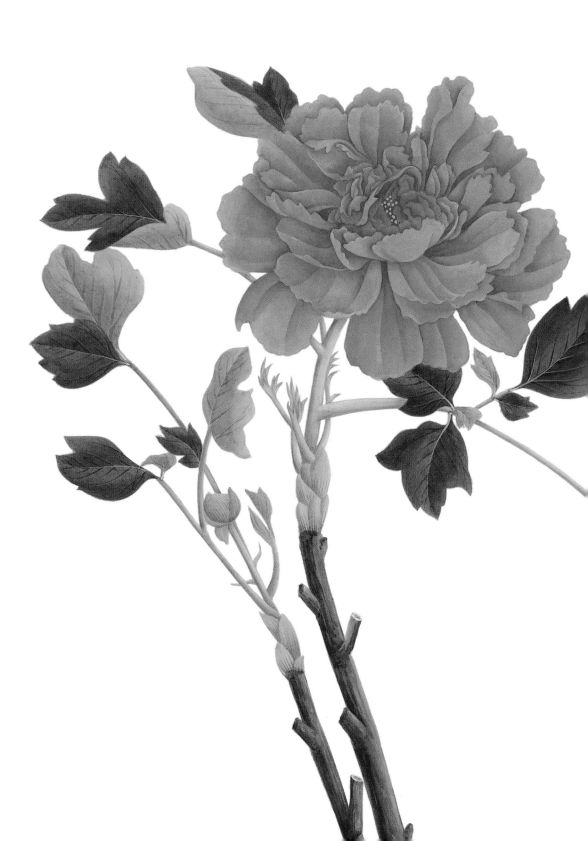

25 Monday

Spring Bank Holiday, UK
Holiday, USA (Memorial Day)

26 Tuesday

27 Wednesday

28 Thursday

29 Friday

Feast of Weeks (Shavuot)

30 Saturday

31 Sunday

First Quarter
Whit Sunday (Pentecost)

A double red cultivar of the tree peony, *Paeonia suffruticosa*.
Drawing by an unidentified Chinese artist from the Reeves collection.

1 Monday

Holiday, Republic of Ireland
Holiday, New Zealand (Queen's Birthday)

2 Tuesday

Coronation Day

3 Wednesday

4 Thursday

5 Friday

6 Saturday

7 Sunday

Full Moon
Trinity Sunday

Rosa 'Parks's Yellow Tea-scented China', double form. Drawing by an unidentified Chinese artist from the Reeves collection.

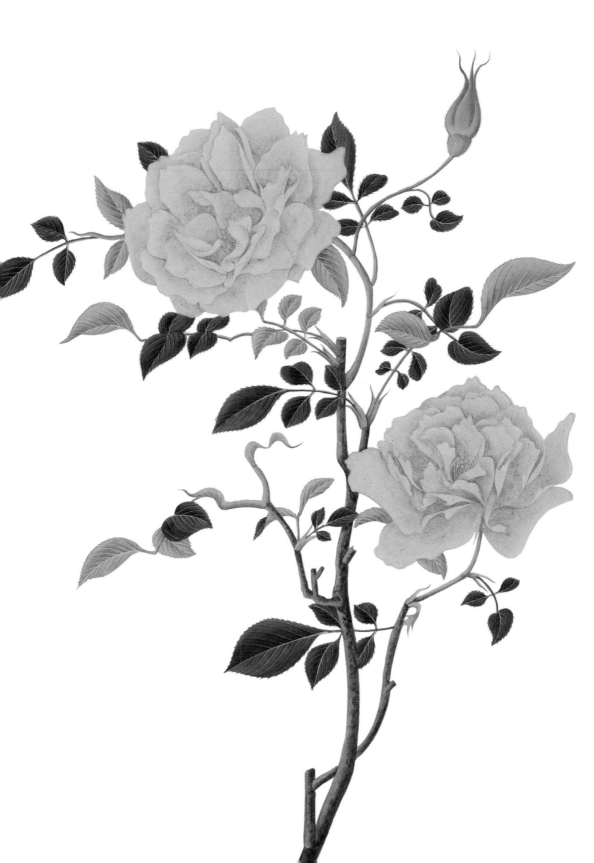

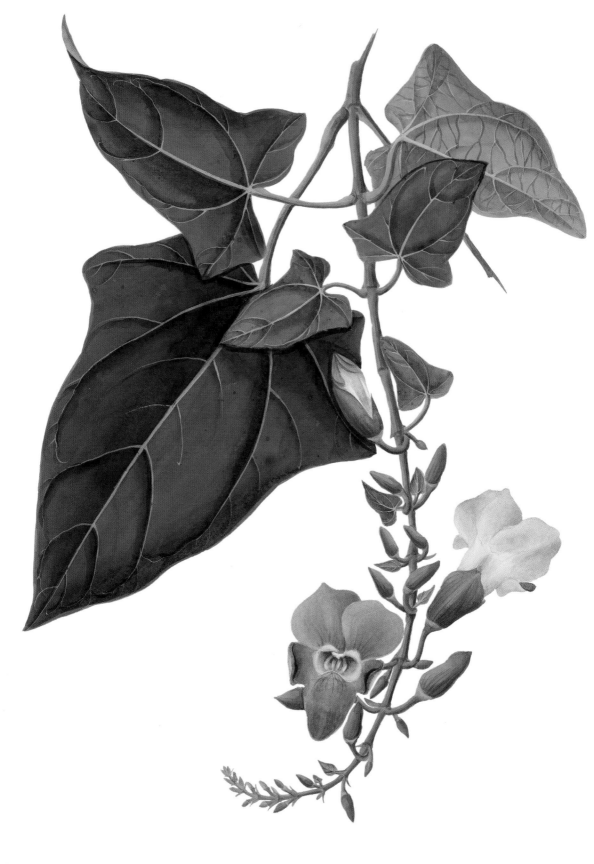

8 Monday

9 Tuesday

10 Wednesday

Wisley Music Festival
BBC Gardeners' World Live, Birmingham

11 Thursday

Corpus Christi
Wisley Music Festival
BBC Gardeners' World Live, Birmingham

12 Friday

Wisley Music Festival
BBC Gardeners' World Live, Birmingham

13 Saturday

The Queen's Official Birthday
Wisley Music Festival
BBC Gardeners' World Live, Birmingham

14 Sunday

BBC Gardeners' World Live, Birmingham

Thunbergia laurifolia. Drawing by an unidentified Chinese artist from the Reeves collection.

15 Monday

Last Quarter
St. Swithin's Day

16 Tuesday

17 Wednesday

18 Thursday

19 Friday

20 Saturday

21 Sunday

Summer Solstice
Father's Day, UK, Canada and USA

Papaver somniferum. Drawing by an unidentified Chinese artist from the Reeves collection.

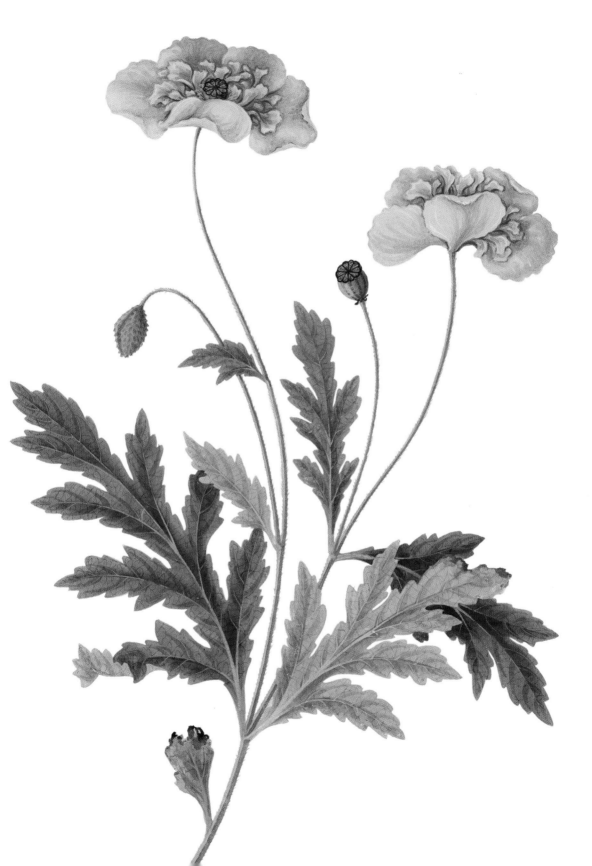

22 Monday

New Moon

23 Tuesday

24 Wednesday

25 Thursday

26 Friday

27 Saturday

28 Sunday

Commelina diffusa. Drawing by an unidentified Chinese artist from the Reeves collection.

29 Monday

First Quarter

30 Tuesday

1 Wednesday

Holiday, Canada (Canada Day)

2 Thursday

3 Friday

Holiday, USA (Independence Day)

4 Saturday

Independence Day, USA

5 Sunday

Hibiscus sinosyriacus. Drawing by an unidentified Chinese artist from the Reeves collection.

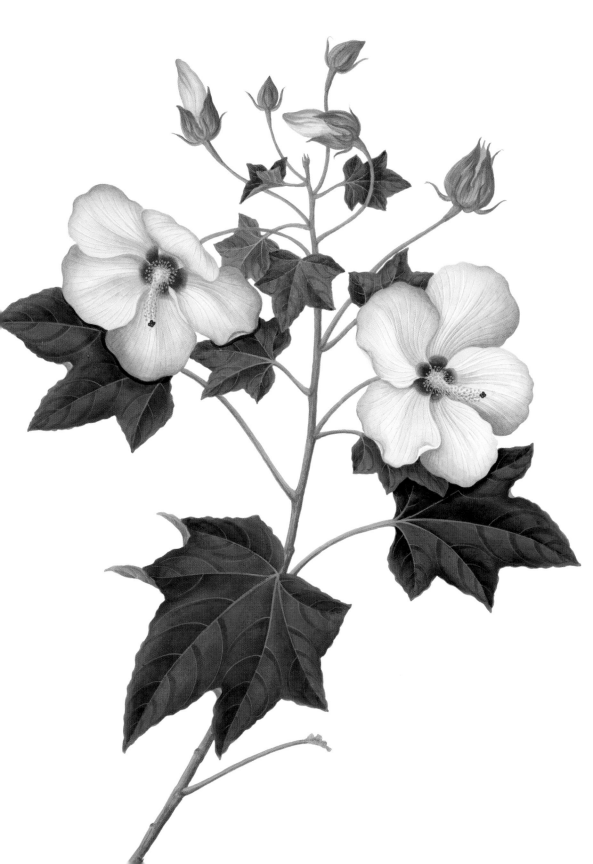

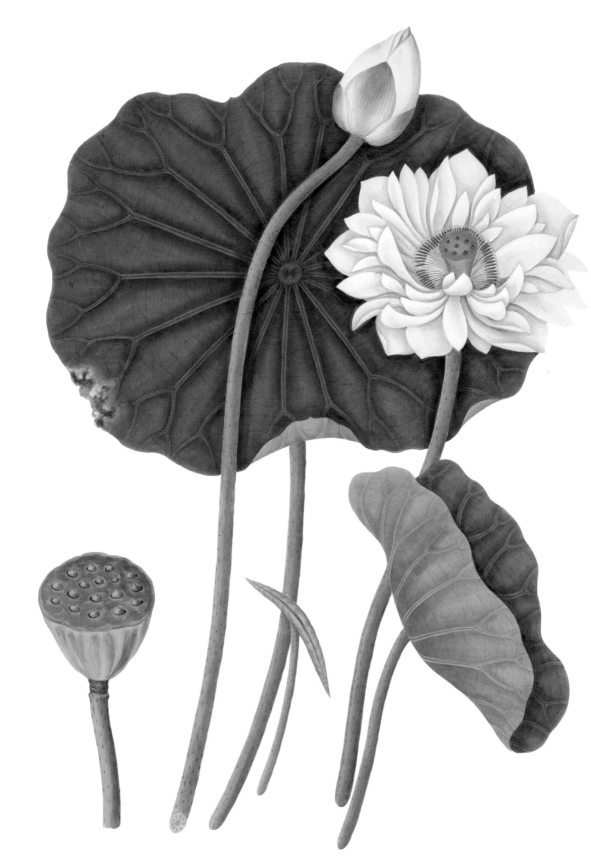

6 Monday

7 Tuesday

Full Moon
RHS Hampton Court Palace Flower Show

8 Wednesday

RHS Hampton Court Palace Flower Show

9 Thursday

RHS Hampton Court Palace Flower Show

10 Friday

RHS Hampton Court Palace Flower Show

11 Saturday

RHS Hampton Court Palace Flower Show

12 Sunday

RHS Hampton Court Palace Flower Show

Nelumbo nucifera. Drawing by an unidentified Chinese artist from the Reeves collection.

13 Monday

Battle of the Boyne
Holiday, Northern Ireland

14 Tuesday

15 Wednesday

Last Quarter

16 Thursday

17 Friday

18 Saturday

19 Sunday

Rosa 'Slater's Crimson', probably the oldest rose cultivar in cultivation, introduced into Britain in the late 18th century.
Drawing by an unidentified Chinese artist from the Reeves collection.

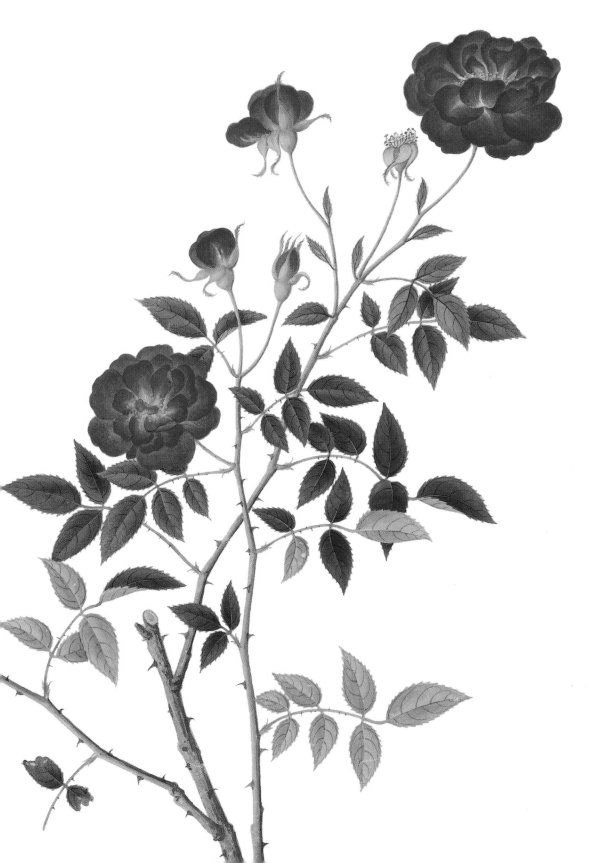

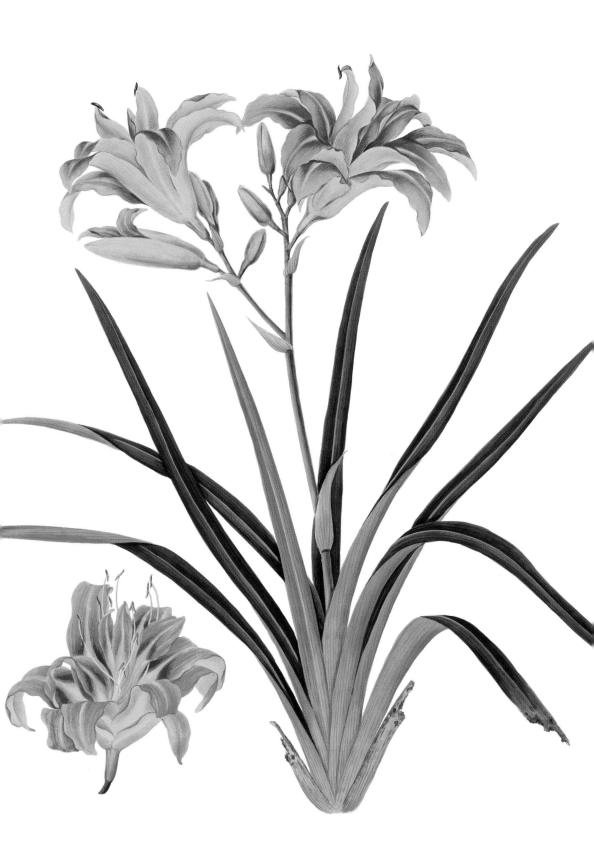

20 Monday

21 Tuesday

22 Wednesday

New Moon
RHS Flower Show at Tatton Park

23 Thursday

RHS Flower Show at Tatton Park

24 Friday

RHS Flower Show at Tatton Park

25 Saturday

RHS Flower Show at Tatton Park

26 Sunday

RHS Flower Show at Tatton Park

Hemerocallis fulva. Drawing by an unidentified Chinese artist from the Reeves collection.

27 Monday

28 Tuesday

First Quarter

29 Wednesday

30 Thursday

31 Friday

1 Saturday

2 Sunday

Lantana camara. Drawing by an unidentified Chinese artist from the Reeves collection.

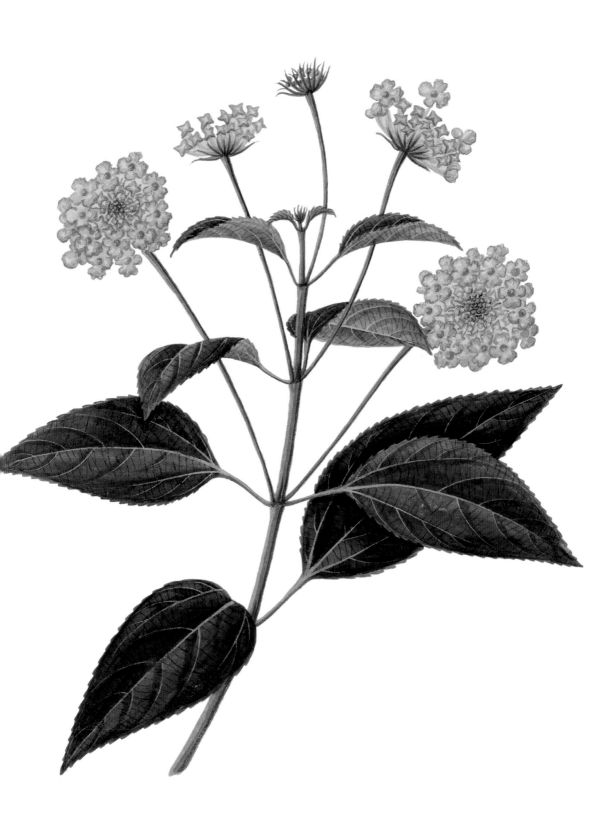

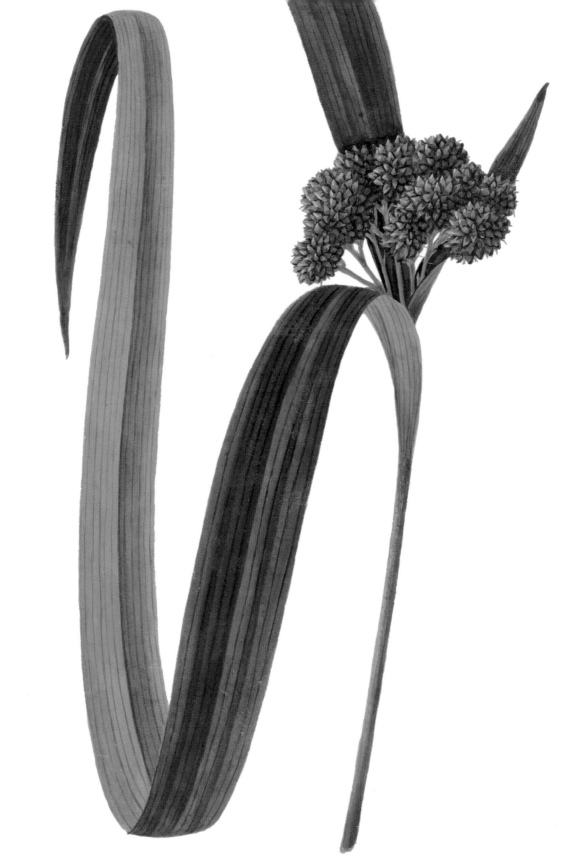

3 Monday

Summer Bank Holiday, Scotland
Holiday, Republic of Ireland

4 Tuesday

5 Wednesday

6 Thursday

Full Moon

7 Friday

8 Saturday

9 Sunday

A species of *Scirpus*. Drawing by an unidentified Chinese artist from the Reeves collection.

10 Monday

11 Tuesday

12 Wednesday

13 Thursday

Last Quarter

14 Friday

15 Saturday

16 Sunday

Curcuma zeodaria. Drawing by an unidentified Chinese artist from the Reeves collection.

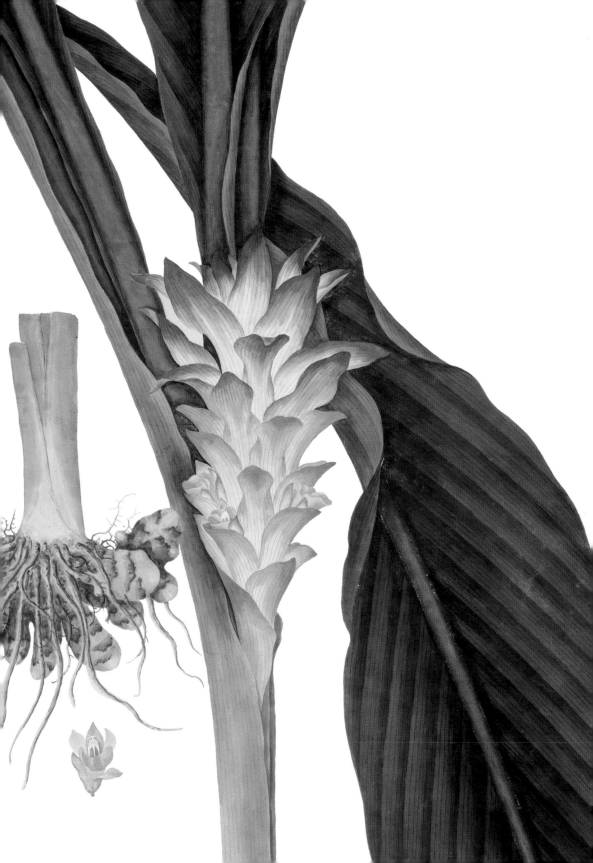

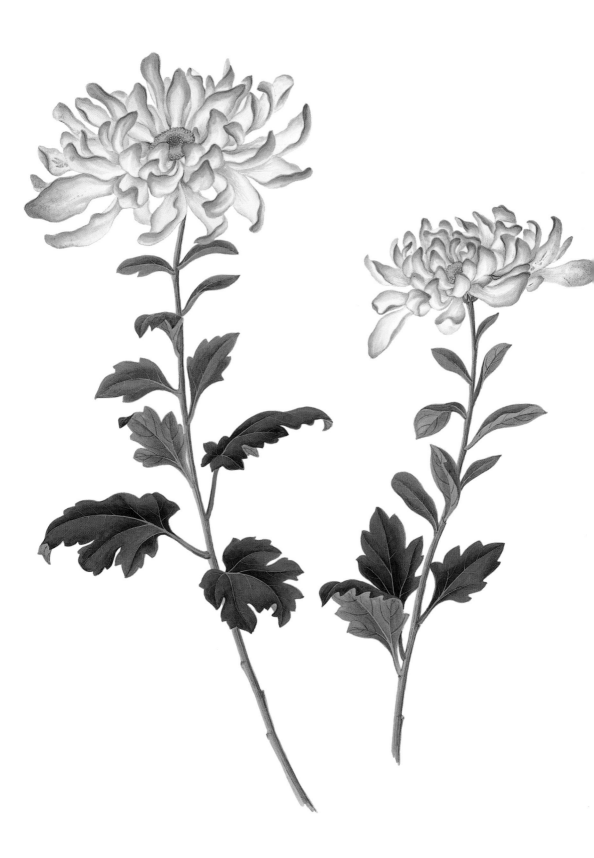

17 Monday

18 Tuesday

RHS Wisley Flower Show

19 Wednesday

RHS Wisley Flower Show

20 Thursday

New Moon
RHS Wisley Flower Show

21 Friday

22 Saturday

First day of Ramadân (subject to sighting of the moon)

23 Sunday

A pink chrysanthemum cultivar. Drawing by an unidentified Chinese artist from the Reeves collection.

24 Monday

25 Tuesday

26 Wednesday

27 Thursday

First Quarter

28 Friday

29 Saturday

30 Sunday

Cucumis pepo, Chinese form. Drawing by an unidentified Chinese artist from the Reeves collection.

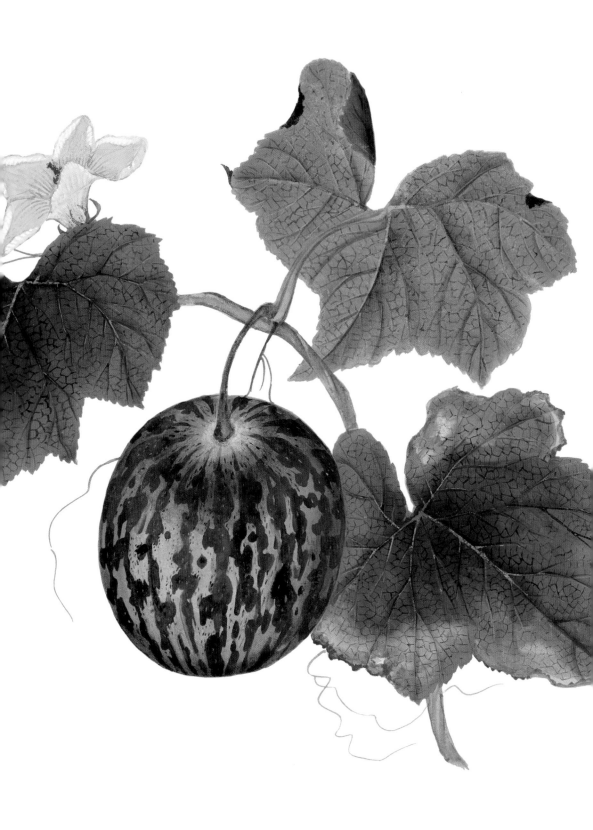

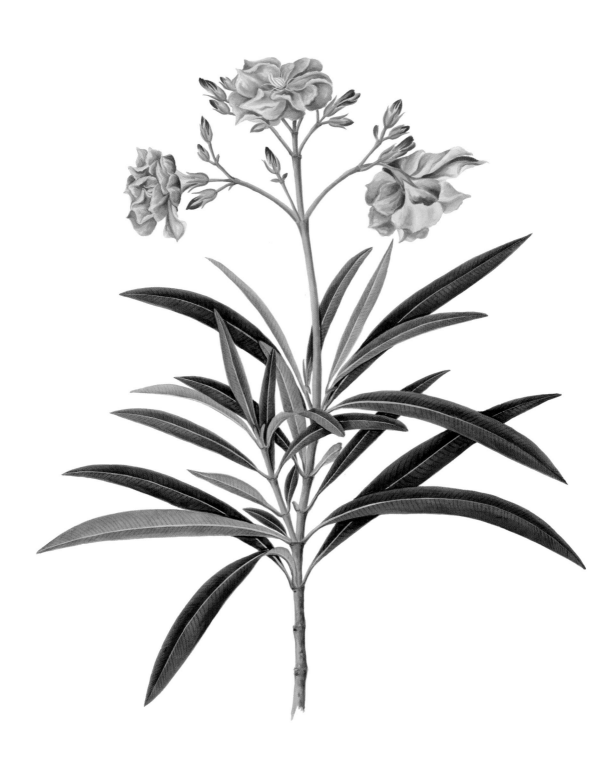

31 Monday

Summer Bank Holiday, UK exc. Scotland

1 Tuesday

2 Wednesday

3 Thursday

4 Friday

Full Moon

5 Saturday

6 Sunday

Father's Day, Australia and New Zealand

Nerium oleander. Drawing by an unidentified Chinese artist from the Reeves collection.

7 Monday

Holiday, USA (Labor Day)
Holiday, Canada (Labour Day)

8 Tuesday

9 Wednesday

10 Thursday

11 Friday

12 Saturday

Last Quarter

13 Sunday

Hydrangea macrophylla. Drawing by an unidentified Chinese artist from the Reeves collection.

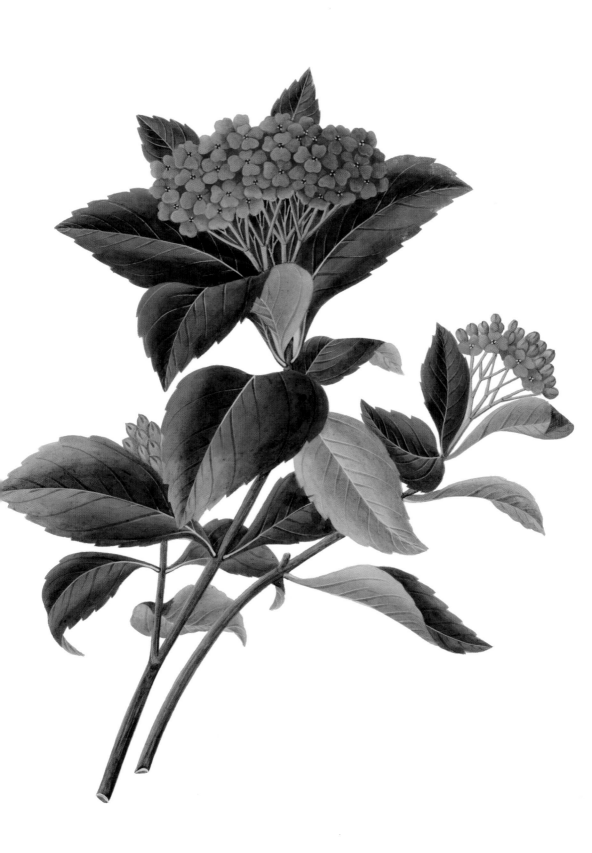

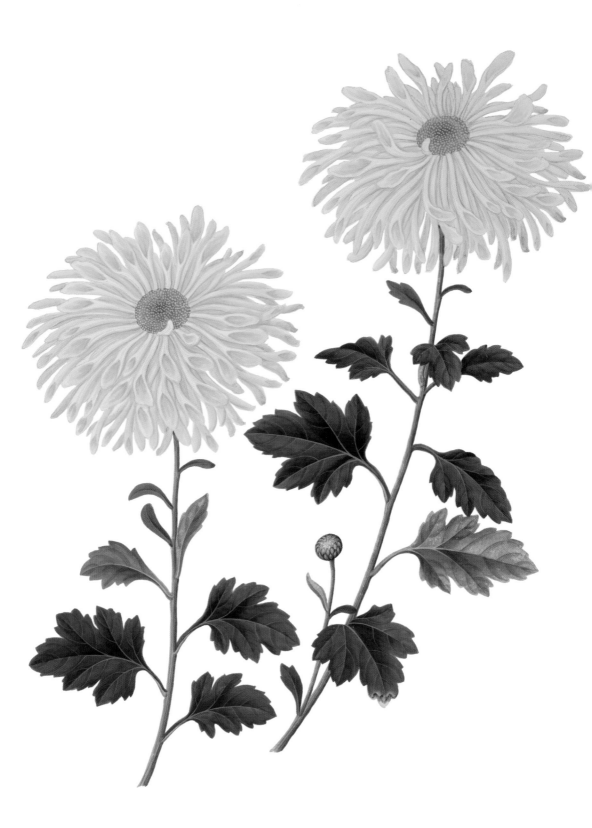

14 Monday

15 Tuesday

16 Wednesday

17 Thursday

18 Friday

New Moon

19 Saturday

Jewish New Year (Rosh Hashanah)

20 Sunday

A semi-double yellow chrysanthemum cultivar of the quilled form.
Drawing by an unidentified Chinese artist from the Reeves collection.

SEPTEMBER

21 Monday

Eid al Fitr, Ramadân ends

22 Tuesday

Autumnal Equinox

23 Wednesday

24 Thursday

25 Friday

26 Saturday

First Quarter
Malvern Autumn Show

27 Sunday

Malvern Autumn Show

Ficus religiosa. Drawing by an unidentified Chinese artist from the Reeves collection.

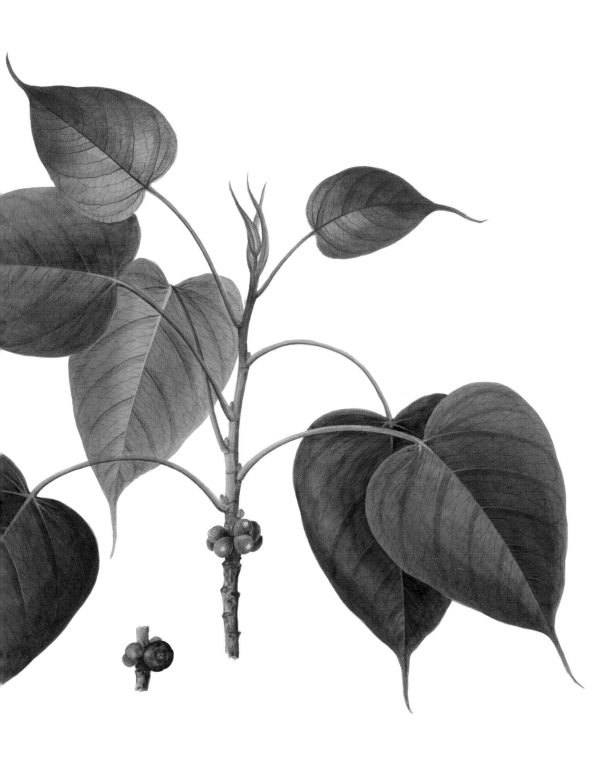

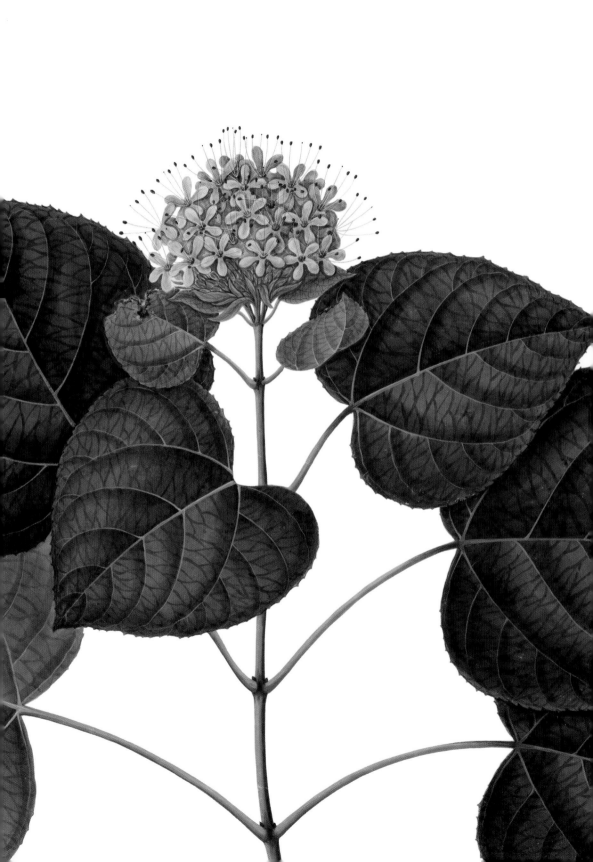

28 Monday

Day of Atonement (Yom Kippur)

29 Tuesday

Michaelmas Day

30 Wednesday

1 Thursday

2 Friday

3 Saturday

Festival of Tabernacles (Succoth), First Day

4 Sunday

Full Moon

The glory flower, *Clerodendrum bungei*. Drawing by an unidentified Chinese artist from the Reeves collection.

5 Monday

6 Tuesday

7 Wednesday

8 Thursday

9 Friday

10 Saturday

Festival of Tabernacles (Succoth), Eighth Day

11 Sunday

Last Quarter

Two chrysanthemum cultivars: 'Large Quilted White' and 'Deep Lilac'.
Drawing by an unidentified Chinese artist from the Reeves collection.

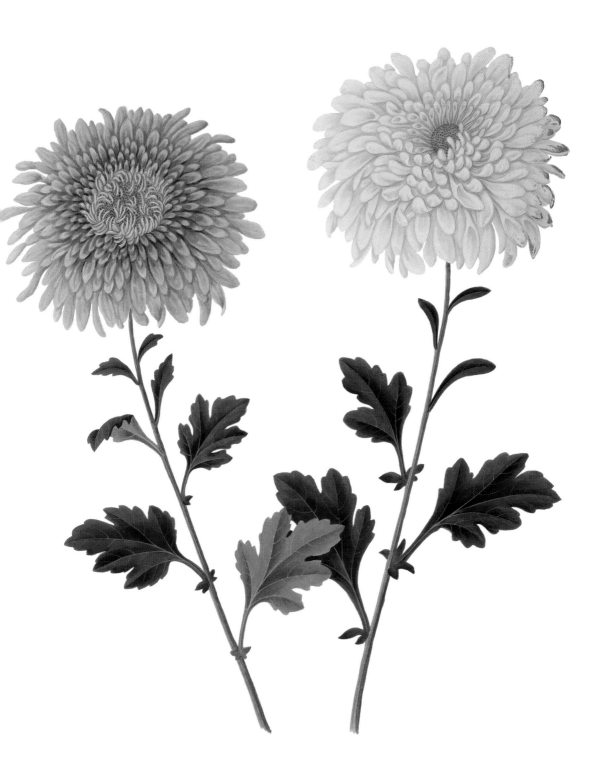

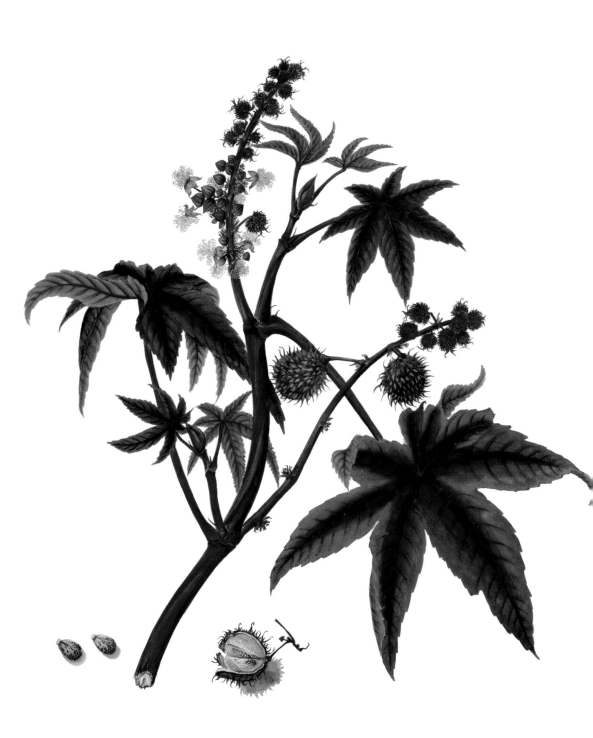

12 Monday

Holiday, Canada (Thanksgiving)
Holiday, USA (Columbus Day)

13 Tuesday

RHS London Autumn Show

14 Wednesday

RHS London Autumn Show

15 Thursday

16 Friday

17 Saturday

18 Sunday

New Moon

Ricinus communis. Drawing by an unidentified Chinese artist from the Reeves collection.

19 Monday

20 Tuesday

21 Wednesday

22 Thursday

23 Friday

24 Saturday

United Nations Day

25 Sunday

British Summer Time ends

Two chrysanthemum cultivars: 'White Waves of Autumn' and 'Yellow Umbrella'.
Drawing by an unidentified Chinese artist from the Reeves collection.

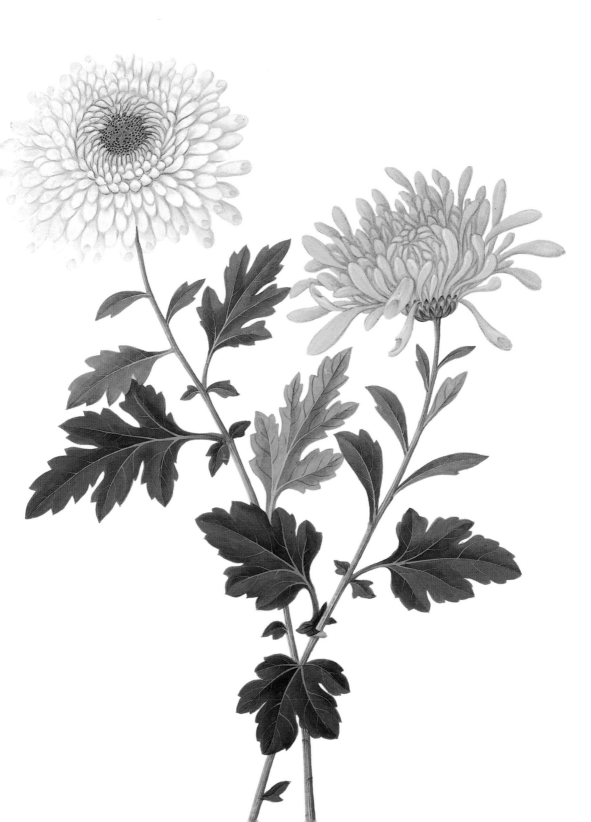

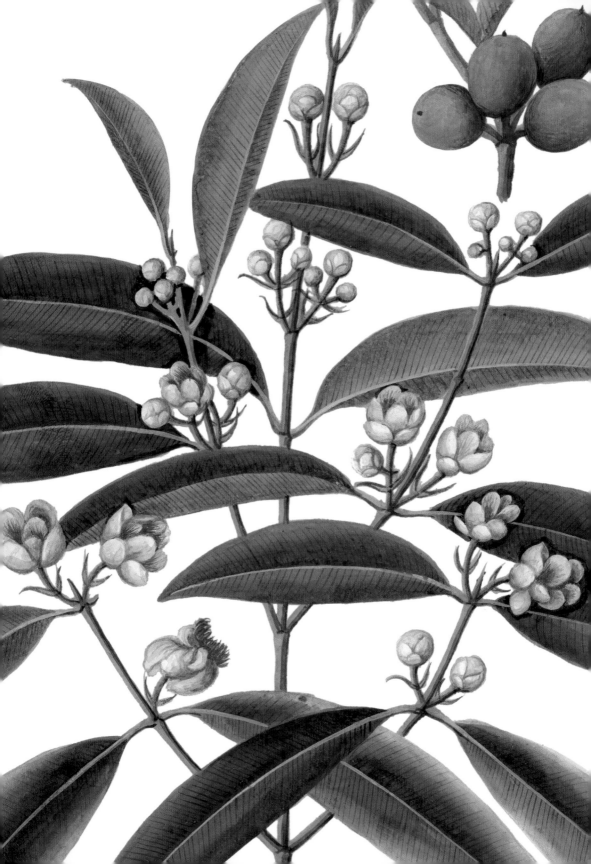

OCTOBER & **NOVEMBER**

26 Monday

First Quarter
Holiday, New Zealand (Labour Day)
Holiday, Republic of Ireland

27 Tuesday

28 Wednesday

29 Thursday

30 Friday

31 Saturday

Hallowe'en

1 Sunday

All Saints' Day

Garcinia griffithii. Drawing by an unidentified Chinese artist from the Reeves collection.

NOVEMBER

2 Monday

Full Moon

3 Tuesday

4 Wednesday

5 Thursday

Guy Fawkes' Day

6 Friday

7 Saturday

8 Sunday

Remembrance Sunday, UK

A semi-double lilac chysanthemum cultivar of the quill type.
Drawing by an unidentified Chinese artist from the Reeves collection.

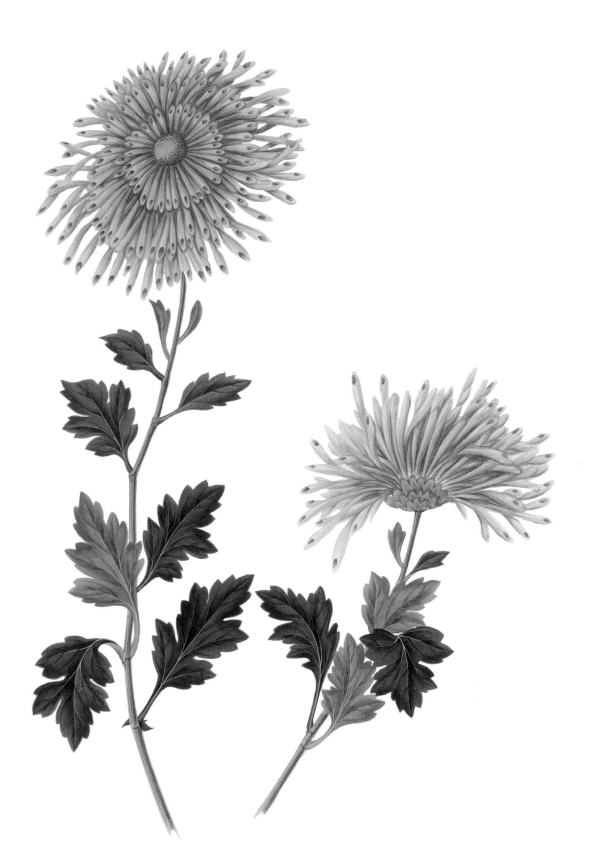

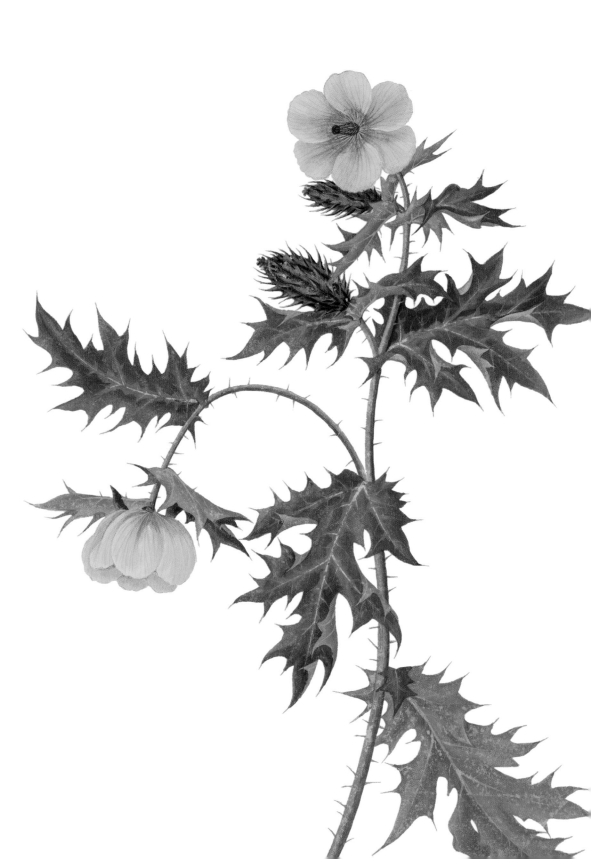

NOVEMBER

9 Monday

Last Quarter

10 Tuesday

11 Wednesday

Holiday, USA (Veterans' Day)
Holiday, Canada (Remembrance Day)

12 Thursday

13 Friday

14 Saturday

15 Sunday

The Mexican poppy, *Argemone mexicana*, introduced into east Asia by the Spaniards.
Drawing by an unidentified Chinese artist from the Reeves collection.

NOVEMBER

16 Monday

New Moon

17 Tuesday

18 Wednesday

19 Thursday

20 Friday

21 Saturday

22 Sunday

Celastrus orbiculatus. Drawing by an unidentified Chinese artist from the Reeves collection.

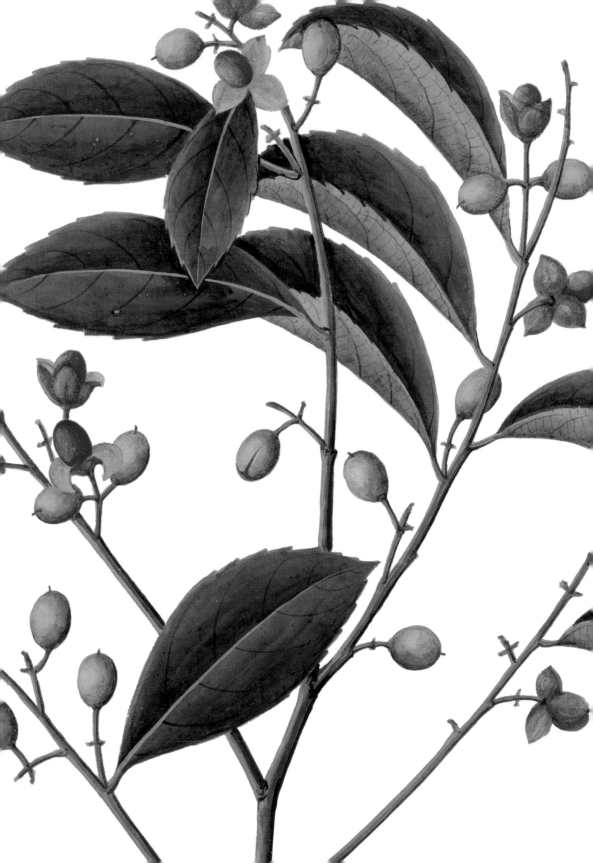

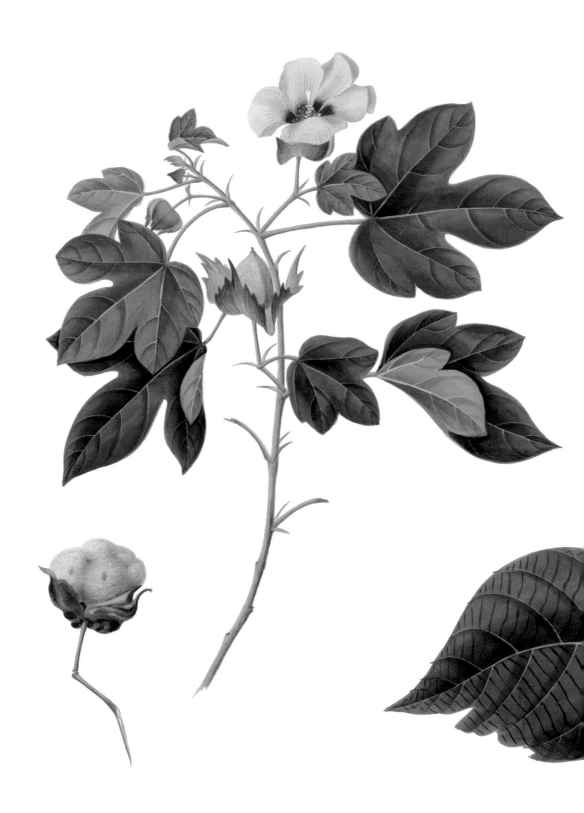

NOVEMBER

23 Monday

24 Tuesday

First Quarter

25 Wednesday

26 Thursday

Holiday, USA (Thanksgiving Day)

27 Friday

28 Saturday

29 Sunday

First Sunday in Advent

Gossypium arboreum. Drawing by an unidentified Chinese artist from the Reeves collection.

NOVEMBER & **DECEMBER**

30 Monday

St. Andrew's Day

1 Tuesday

2 Wednesday

Full Moon

3 Thursday

4 Friday

5 Saturday

6 Sunday

Carissa carandas. Drawing by an unidentified Chinese artist from the Reeves collection.

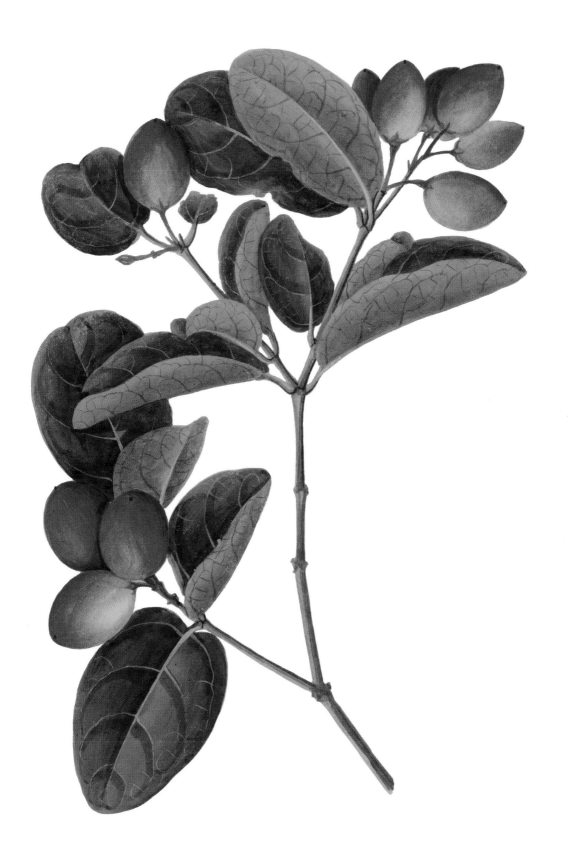

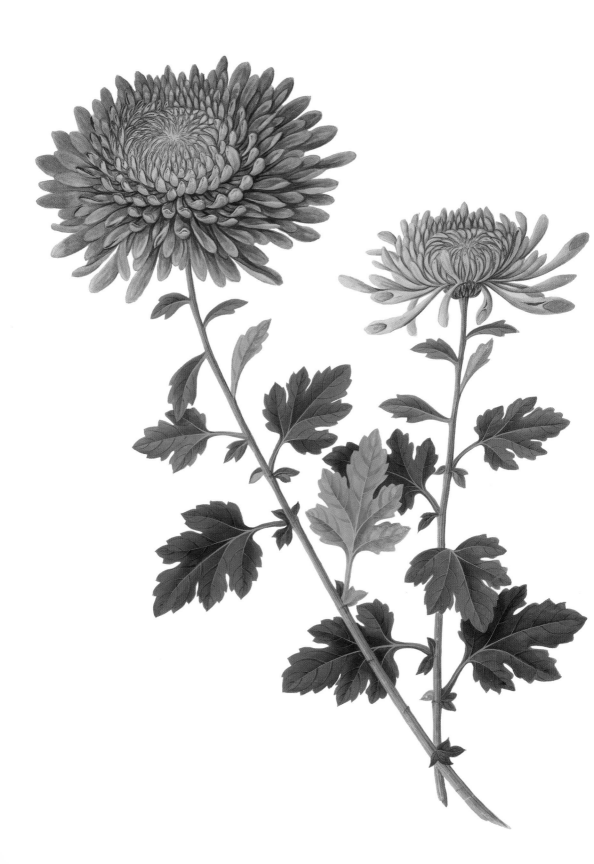

DECEMBER

7 Monday

8 Tuesday

9 Wednesday

Last Quarter

10 Thursday

11 Friday

12 Saturday

Jewish Festival of Chanukah, First Day

13 Sunday

Chrysanthemum 'Large Lilac'. Drawing by an unidentified Chinese artist from the Reeves collection.

DECEMBER

14 Monday

15 Tuesday

16 Wednesday

New Moon

17 Thursday

18 Friday

Islamic New Year (subject to sighting of the moon)

19 Saturday

20 Sunday

The kumquat, *Fortunella margarita*. Drawing by an unidentified Chinese artist from the Reeves collection.

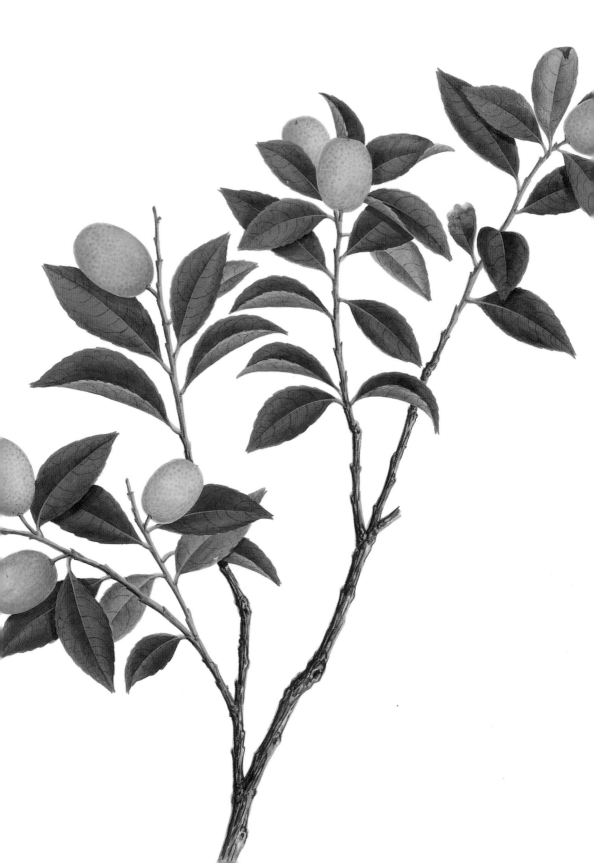

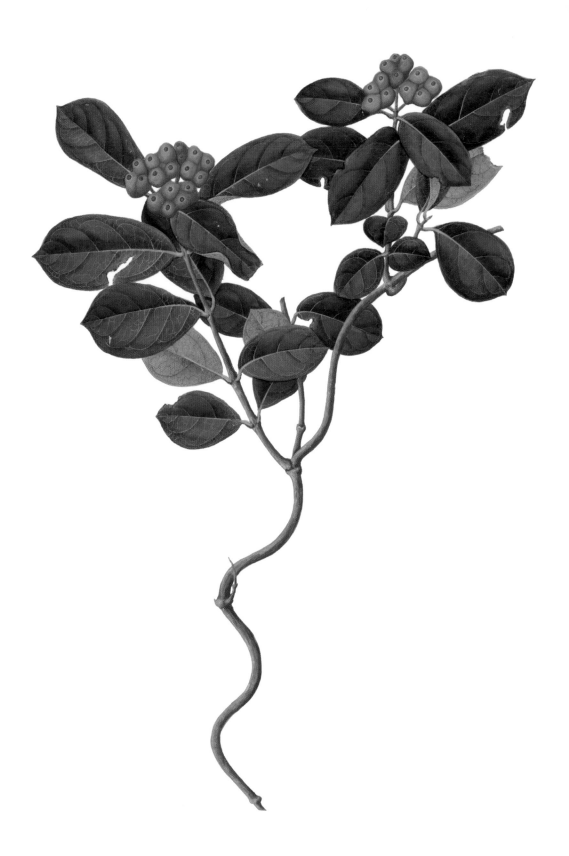

DECEMBER

21 Monday

Winter Solstice

22 Tuesday

23 Wednesday

24 Thursday

First Quarter
Christmas Eve

25 Friday

Christmas Day
Holiday, UK, Republic of Ireland, Canada, USA,
Australia and New Zealand

26 Saturday

Boxing Day (St. Stephen's Day)

27 Sunday

Ixora chinensis, showing its berries. Drawing by an unidentified Chinese artist from the Reeves collection.

28 Monday

Holiday, UK, Canada, New Zealand and Australia

29 Tuesday

30 Wednesday

31 Thursday

Full Moon
New Year's Eve

1 Friday

New Year's Day
*Holiday, UK, Republic of Ireland, Canada, USA,
Australia and New Zealand*

2 Saturday

Holiday, Scotland and New Zealand

3 Sunday

Unnamed cultivar of *Camellia japonica*. Drawing by an unidentified Chinese artist from the Reeves collection.

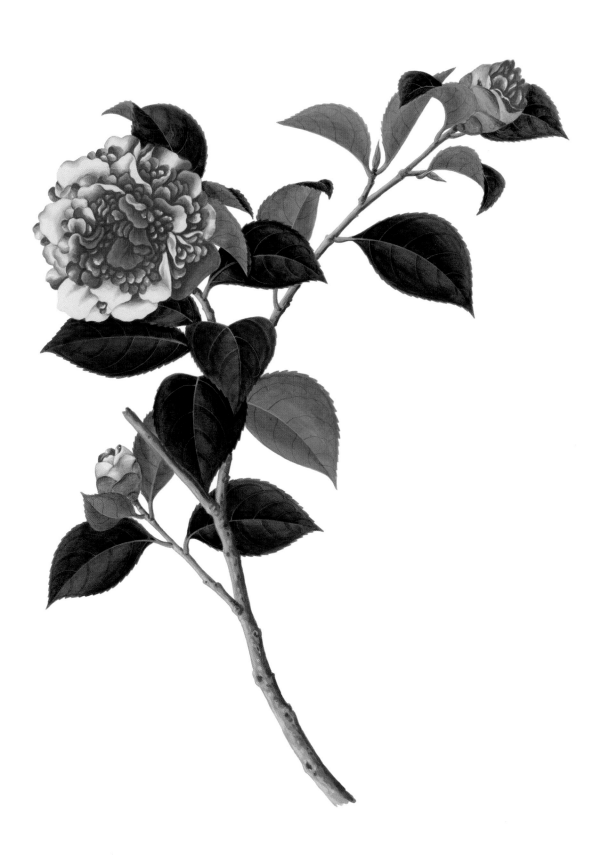

EUROPEAN NATIONAL HOLIDAYS 2009

AUSTRIA JAN 1, 6; APR 12, 13; MAY 1, 21, 31; JUN 1, 11; AUG 15; OCT 26; NOV 1; DEC 8, 25, 26

BELGIUM JAN 1; APR 12, 13; MAY 1, 21, 31; JUN 1; JUL 11, 21; AUG 15; SEP 27; NOV 1, 11, 15; DEC 25

BULGARIA JAN 1; MAR 3; APR 19, 20; MAY 1, 6, 24; SEP 6, 21, 22; NOV 1; DEC 24, 25, 26

CROATIA JAN 1, 6; APR 10, 12, 13; MAY 1; JUN 11, 22, 25; AUG 5, 15; OCT 8; NOV 1; DEC 25, 26

CYPRUS JAN 1, 6; MAR 2, 25; APR 1, 17, 19, 20; MAY 1; JUN 7, 8; AUG 15; OCT 1, 28; DEC 25, 26

CZECH REPUBLIC JAN 1; APR 12, 13; MAY 1, 8; JUL 5, 6; SEP 28; OCT 28; NOV 17; DEC 24, 25, 26

DENMARK JAN 1; APR 9, 10, 12, 13; MAY 8, 21, 31; JUN 1, 5; DEC 25, 26

ESTONIA JAN 1; FEB 24; APR 10, 12; MAY 1, 31; JUN 23, 24; AUG 20; DEC 24, 25, 26

FINLAND JAN 1, 6; APR 10, 12, 13; MAY 1, 21, 31; JUN 20; OCT 31; DEC 6, 25, 26

FRANCE JAN 1; APR 10, 12, 13; MAY 1, 8, 21, 31; JUN 1; JUL 14; AUG 15; NOV 1, 11; DEC 25

GERMANY JAN 1, 6; APR 10, 12, 13; MAY 1, 21, 31; JUN 1, 11; AUG 15; OCT 3, 31; NOV 1, 18; DEC 25, 26

GREECE JAN 1, 6; MAR 2, 25; APR 17, 19, 20; MAY 1; JUN 7, 8; AUG 15; OCT 28; DEC 25, 26

HUNGARY JAN 1; MAR 15; APR 12, 13; MAY 1, 31; JUN 1; AUG 20, 21; OCT 23; NOV 1; DEC 25, 26

ITALY JAN 1, 6; APR 12, 13; 25; MAY 1; JUN 2; AUG 15; NOV 1; DEC 8, 25, 26

LATVIA JAN 1; APR 10, 12, 13; MAY 1, 4; JUN 22, 23, 24; NOV 18; DEC 25, 26, 31

LITHUANIA JAN 1; FEB 16; MAR 11; APR 12, 13, 14; MAY 1, 3, 4; JUN 24; JUL 6; AUG 15,17; NOV 1, 2; DEC 25, 26, 28

LUXEMBOURG JAN 1; FEB 23; APR 12, 13; MAY 1, 21, 31; JUN 1, 23; AUG 15; SEP 7; NOV 1; DEC 25, 26

MALTA JAN 1; FEB 10; MAR 19, 31; APR 10, 12; MAY 1; JUN 7, 29; AUG 15; SEP 8, 21; DEC 8, 13, 25

NETHERLANDS JAN 1; APR 10, 12, 13, 30; MAY 21, 31; JUN 1; DEC 25, 26

NORWAY JAN 1; APR 9, 10, 12, 13; MAY 1, 17, 21, 31; JUN 1; DEC 25, 26

POLAND JAN 1; APR 12, 13; MAY 1, 3; JUN 11; AUG 15; NOV 1, 11; DEC 25, 26

PORTUGAL JAN 1; FEB 24; APR 10, 12, 13, 25; MAY 1; JUN 10, 11, 13; AUG 15; OCT 5; NOV 1; DEC 1, 8, 25

ROMANIA JAN 1, 2; APR 19, 20; MAY 1; DEC 1, 25, 26

SLOVAKIA JAN 1, 6; APR 10, 12, 13; MAY 1, 8; JUL 5; AUG 29; SEP 1, 15; NOV 1, 17; DEC 24, 25, 26

SLOVENIA JAN 1, 2; FEB 8; APR 12, 13, 27; MAY 1, 2, 31; JUN 25; AUG 15; OCT 31; NOV 1; DEC 25, 26

SPAIN JAN 1, 6; APR 9, 10, 12, 13; MAY 1, 31; AUG 15; OCT 12; NOV 1, 9; DEC 6, 8, 25, 26

SWEDEN JAN 1, 6; APR 10, 12, 13; MAY 1, 21, 31; JUN 6, 20; OCT 31; DEC 25, 26

SWITZERLAND JAN 1, 2; APR 10, 12, 13; MAY 1, 21, 31; JUN 1; AUG 1, 15; NOV 1; DEC 8, 25, 26